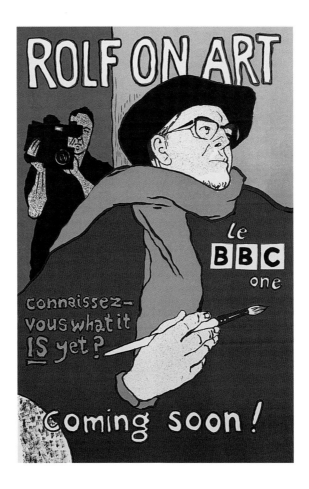

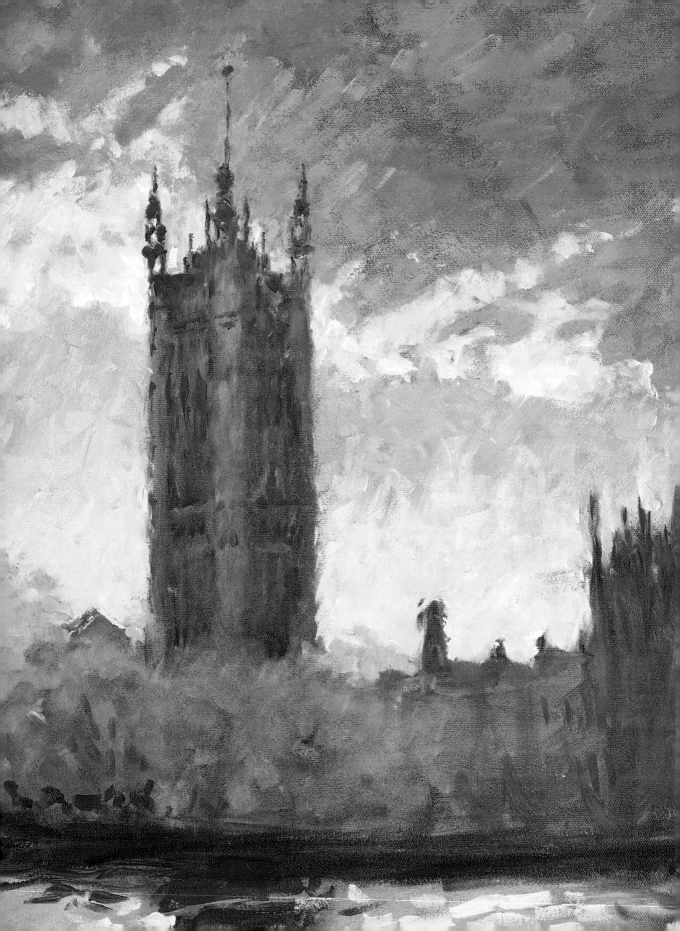

ROLF ON ART

MY APPROACH FROM FIRST STEPS
TO FINISHED PAINTINGS

ROLF HARRIS

BBC

To Alwen and Bindi, my partners in art

My thanks to Sarah Hargreaves, Executive Producer of
Rolf on Art, who first approached me with the idea for
the programme, and then made it happen. To Lorraine
Heggessey, Controller of BBC1, for giving it her total
encouragement and backing. To Tina Fletcher, Series
Producer, who achieved her aim of reaching out to
would-be artists – and non-artists – of all ages, and
inspiring them to have a go. To the huge team at the
BBC who brought it all to fruition. To Flicka Lister for
the words, and Richard Palmer for the photography,
that brought the book together. To my brother Bruce
and Jan Kennedy, my managers, for their continuing
support. And finally, to Pat Lake-Smith, and to Lisa
Ratcliff and Suzanne Westrip at Billy Marsh Associates
for their constant hard work and dedication.

This book is published to accompany the second
series of *Rolf on Art*, first broadcast on BBC1 in 2002.

Executive Producer: Sarah Hargreaves
Series Producer: Tina Fletcher

Published by BBC Worldwide Ltd, Woodlands,
80 Wood Lane, London W12 0TT

First published 2002
Copyright © Rolf Harris 2002
The moral right of the author has been asserted.

ISBN 0 563 48852 2

Commissioning Editor: Nicky Copeland
Project Editor: Flicka Lister
Designer: Isobel Gillan
Photography: Richard Palmer
Picture Researcher: Rachel Jordan
Production Controller: Christopher Tinker

Set in Helvetica Neue
Printed and bound in Italy by LEGO SpA
Colour separations by Kestrel Digital Colour, Witham

Contents

Introduction 6

My approach to impressionism 8

THE WAY I WORK
Materials and equipment 10
Mixing colours 12
Composition 14
Measuring 16
Painting people 17
Sketching 20

CLOSE ENCOUNTERS of the
ARTISTIC KIND

Claude Monet 24
The Water Lily Pond, Giverny 26
The Houses of Parliament 28

Edgar Degas 30
After the Bath 32
The Jockey 34

Vincent Van Gogh 36
The Church at Auvers 38
My Self Portrait 40
Sunflowers 42

Paul Gauguin 44
Rolf's Dream 46
Tropical Vegetation 48

Henri Rousseau 50
My Self Portrait 51
The Hungry Lion 52

Henri de Toulouse-Lautrec 54
Rolf's Poster 55
Cancan at the Moulin Rouge 56

Gustav Klimt 58
The Kiss 59
Golden Jubilee Frieze 60

Auguste Rodin 62
Bindi's Hands 63
Rolf's Thinker 64

STEP into MY STUDIO

Love at Low Tide 68

Running into the Dusk 74

Still Life 82

Durham Cathedral 92

The Didgeridoo Player 100

Sunrise at Bray 108

South London Flower Seller 116

A Question of Art... 124

Index 128

Introduction

When I was approached to do the first *Rolf on Art* television series on impressionism, painting in the styles of Monet, Degas, Van Gogh and Gauguin, I was thrilled. I came to England to study art in the 1950s. During this time, I met the impressionist painter Hayward Veal (known to his friends as Bill), whose paintings I'd loved as a teenager in Australia. His influence on my work was profound: he provided me with the ammunition and knowledge to produce the huge paintings that were my signature on television in the 1960s and 1970s, and still are today.

In the second *Rolf on Art* television series, I explored the work of four further great artists – Rousseau, Toulouse-Lautrec, Klimt and Rodin – another wonderful journey of discovery, which proved to me that you should never stop learning or broadening your field of endeavour.

With this book, I'm thrilled to be able to share all these experiences with you, while welcoming you into my own studio to find out more about the way I work: the colours I use, my techniques, equipment and the many things that inspire me. I paint the whole canvas as a blur, as though my eyes are de-focused and half-closed, and then refine it to the degree I want. To the painters who draw an outline of everything they see and then fill in these map lines with different colours, this will be a completely different technique – I do hope you enjoy joining me and have fun trying some painting of your own with my approach.

My approach to impressionism

Until I met Bill Veal, I was a competent natural painter, who drew outlines carefully, then filled them in with colour. Bill showed me a wonderful approach to painting in an impressionistic way. He liked to have his palette organized – the various chunks of colour he'd mixed on his palette would reflect exactly the colours on his canvas. This meant using as few main colours in as many different ways as he could. Bill taught me the importance of tonal relationships and of not being afraid to change things that don't work. If you mix a colour and put it on and it's wrong, you can just lift it off with a bit of rag and turpentine, remix it and do it again. I also found out that you shouldn't paint on top of one wet colour with a different one, if you want the new colour to stay clean. Always lift off wet paint before applying a new colour, or your paint will turn to mud.

▼ Still Life with Blue Bottle
Hayward Veal
Oil on canvas
40 x 50 cm (16 x 20 in)
Author's collection

An exercise in monochrome

The first painting that I did for Bill was of daffodils against a dark background. When I tried to put bright yellow on top of the wet background, it turned to a brown. He took me away and gave me a blank canvas, a brush, just one tube of paint – Burnt Sienna – some rag and a bottle of turpentine. I was amazed that he wanted me to paint in monochrome. He got me to set up a 'still life', and told me to paint the whole canvas as a blur using turps and as little paint as possible, then to refine my blur by looking for the biggest difference between my blur and the subject, forgetting fine detail.

The brown area I'd painted to the left wasn't dark enough, so I fixed it. He told me to move on to what I felt was the next main difference. This was where some light should have been reflected. Bill told me to

get a bit of turps on my rag and take the colour off to make it lighter. Next was the shape of the bottle. 'Don't call it a bottle – think of it as a light-coloured shape,' he said. That was his best advice of all – not to paint things you know, but to paint shapes and tones.

We kept refining it and, in the end, I had used hardly any paint at all, and finished up with a marvellous impressionistic still life of the table and three bottles. I wish I had it still. It was a revelation. I recently decided to paint a friend's baby in exactly the same way, using just one colour. It's a good introduction to impressionism – why don't you try a similar exercise?

Looking for shape and form

When painting an impressionistic picture, you first need to decide whether it is a dark subject surrounded by light or a light subject surrounded by dark like my *Still Life* on page 82.

When looking at a subject to start painting an impression of it, I close my eyes, almost to slits, so that only a fraction of light gets through. All the tiny detail disappears – you just see basic light and dark (it's almost like looking through smoked glass). You can also blur your eyes by holding your thumb up about 30 cm (12 in) from your face. Shut one eye and focus on the thumb with your best eye. Then, keeping the same condition of focus, drop the thumb down and you should have your subject in a totally blurred image, like an out-of-focus photograph. Of course, I'm lucky – being short-sighted, if I take off my glasses, I can't see an in-focus version of my subject even if I want to!

Another important tip, of course, is to look through an out-of-focus camera lens. When everything is a blur, the important lights and darks leap out of the picture (see below). Bring it slightly more into focus, and you start getting more shape and differences of tone.

◀ **Baby Blues**
Rolf Harris
Oil on canvas
40 x 30 cm (16 x 12 in)

◀ An out-of-focus camera lens gives an impressionistic blur. This photograph shows the set-up for my painting *Still Life* on page 82.

THE WAY I WORK

I hope that you will enjoy finding out more about my approach to painting – the step-by-step demonstrations later in the book will allow you to follow me closely, from first steps to finished paintings. But first a few words about the materials I use and how I work...

MATERIALS AND EQUIPMENT

Although I do work in other mediums in this book, most of the paintings were done in oils. Oil paint is a wonderful medium, and I would definitely recommend it if you are a beginner because it's very forgiving – if you make a mistake, you can either rub it off your canvas quite easily, or let it dry and paint over it.

Colours

I suggest you start with ten colours: Cadmium Yellow, Lemon Yellow, Yellow Ochre, Cadmium Red, Magenta, French Ultramarine, Cerulean Blue, Burnt Umber, Black and Titanium White. Of course, you can add other colours as you need them.

Oils come in two different grades: students' and artists' colours. Students' colours are less expensive but perfectly suitable for the beginner. In fact, I use both.

◀ I've just had a studio purpose-built at home and fitted it with daylight neon lights, so I can work at any hour of the day or night. It's marvellous – you can't get me out of it!

Brushes

The most important advice I can give is to have lots of brushes when painting in oils, so that you can use a different brush for each mixed colour, and don't have to keep cleaning them. Four sizes of brush should get you started – a big, round-ended filbert brush for large areas, a medium flat-ended brush for general work, a small round-ended brush for small areas, and a tiny soft nylon or sable 'rigger' for detail. When you have become familiar with these, you can experiment with different ones.

Make your brushes work for you, and remember, the bigger the brush, the braver and less fiddly you get! You will find that, with practice, you can use a brush in dozens of ways, even creating tiny detail in some other coloured area by using the edge of a fairly large brush. I hope that the close-up demonstration photographs later in this book will help you to discover lots of interesting brush techniques and how to use them.

Palette

You need a large area on which to mix your colours. I made my well-used palette out of plywood in the 1950s. For a starter palette, you could use an old dinner plate or a sheet of hardboard. You can also buy books of tear-off disposable oil-proof paper palettes from art shops.

Palette knife

Although you use this for mixing colours on the palette, you can also lay paint on your canvas with it instead of a brush.

Mediums

You can mix your paints with a medium to blend them and sometimes thin the colour. To start a painting, I use pure turpentine but if you don't like the smell, try low-odour thinners. I also use linseed oil, which dries more slowly but gives the paint a nice, smooth application.

Both mediums are kept in 'dippers', small metal containers that clip onto the side of your palette, although you could use jam jar lids instead.

▶ Do you like my improvised brush-holder, made from oasis, the stuff flower arrangers use? I've reinforced it with parcel tape. It helps me keep my different brushes with their different colours organized, ready for when I need them. It's a bit scruffy, but it does the trick!

▲ My adjustable easel

Painting surfaces

You can paint on many different surfaces, provided they have been primed first (i.e. sealed to stop the oil in the paint seeping into the surface beneath). I use ready-primed canvas, canvas board, and also the smooth side of hardboard, which can be primed with ordinary household emulsion paint. Oil sketching paper is great for practising on.

Easel

I use an adjustable easel, so that I can move the canvas up or down depending on whether I'm standing or sitting. I also have an old, blackboard-type easel with holes up the sides for pegs to rest the canvas on. When painting in oils, it's important that the surface you're painting on is nearly upright. If you can't afford an easel, you can use a kitchen chair to prop your painting on.

Other things

You will need a jam jar for turpentine to wash your brushes, plenty of rags (I cut up old t-shirts into little pieces) and a roll of paper towel for mopping up, taking the bulk of the paint off your dirty brushes before dunking them in the turps, and wiping your hands.

MIXING COLOURS

Primary colours (reds, blues and yellows) can't be made by mixing other colours. Secondary colours are the colours made from mixtures of two primaries: basically, red + blue makes purple, blue + yellow makes green, and red + yellow makes orange, but it does depend upon which primary colour you start with. Cadmium Red, for instance, is slightly orange and you would be hard-pressed to get a good purple by mixing blue into it, because you would just get a dirty-looking purple. You should start off with a bluey red, such as Rose Madder or Alizarin Crimson. (Of course, you can also buy greens, purples and oranges in tubes.) You can then go on to mix primary colours with secondary ones; for example, red + green makes brown.

Mixing greys

Although I sometimes add black or white paint to make darker or lighter colours, if they are mixed together on their own, they make a very boring, neutral grey. The three primary colours mixed together always make you a dark grey. You can make it a yellowish-grey by adding more yellow, a reddish-grey by adding more red, etc. Then you can add as much white as you want, to create the *tone* of grey you want.

▲ Four different grey colour mixes

▼ A colour wheel

Complementary colours

Complementary colours are those that react most with each other and are the colours that are opposite one another on a colour wheel – red and green, yellow and violet, and blue and orange. Complementary colours play a central role in painting because, when they are juxtaposed, they set up a kind of vibration that makes both appear brighter.

If I know a picture is going to be predominantly one colour, I often begin by covering the canvas with its complementary colour and, while painting, leave this showing through in places to give the finished picture depth and sparkle. The Impressionists often used this technique, claiming that every shadow contained touches of the complementary colour of the object. You can see how I've started with an orange canvas for the predominantly blue *Love at Low Tide* on page 68.

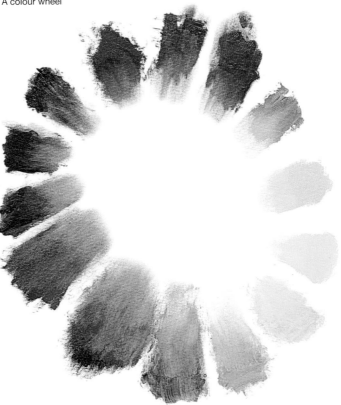

COMPOSITION

The golden rule is make your painting look good for you. I learned this when I painted a Spanish village up on a hill. There were great big poplars off on the left and they were all being blown by the wind.

When I came back and I showed it to Bill Veal, he said, 'It's a pity you've got the poplars leaning out of the picture.' I explained that this was the way the wind had been blowing them. 'You've got the canvas,' he said. 'You're in charge. Don't feel you've got to copy things like a camera. If you want to make a better composition, imagine the wind is blowing in the other direction and angle the poplar tops to the right so that they lead your eye back in towards the village.'

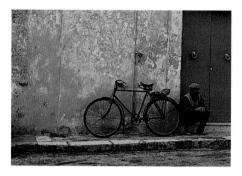

Using photographs

It's a good discipline to look at photographs and think, 'Is that a nice composition?' and, if it is, 'How would I paint it – how would I tackle that sky?'

I often paint from photographs – I must have taken thousands of slides since the early 1960s, when I first got a decent camera, and still take lots of photographs today. Recently I turned the very best ones into prints and had them enlarged to A3 size, so I've got lots of ideas ready if I want to do a painting.

The photo (above) shows a man sitting in total despair next to his bike. He was facing out of the picture and I felt it would

make better composition to have him looking the other way. It *can* be nice to have something that isn't a perfect composition, with bit of mystery to it, but I felt having him facing left would work better here. So I scanned the photograph, reversed the direction of the man, printed it, and used that for reference, leaving the bike in its original position.

The wonderful old wall against which the man was sitting had been repainted dozens of times – it was such a random mix of all sorts of colour washes and, in contrast, the two huge doors to the right of where he's sitting had been painted a dark green gloss. I just loved trying to reproduce this fantastic effect in a painterly way.

▼ **Man with Bike, Malta**
Oil on canvas
38 x 78 cm (15 x 31 in)

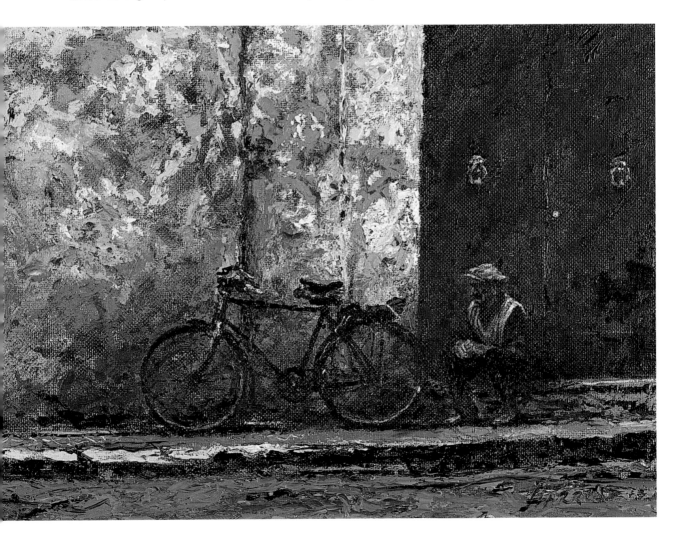

MEASURING

In order to establish the correct proportions of things in your picture in relation to each other, you need to measure the real-life scene first, then transfer these measurements in the right scale to your canvas.

First find a 'key measure' to use throughout your picture by holding your brush at right angles to your arm, at arm's length. Close one eye and use your thumb as a measuring marker. In the photograph (above, left) I am taking my key measure from the top of the head to the chin of Shining Bear, the didgeridoo player I painted on page 100.

The next photo shows me taking a key measure for the same area on my canvas. In the scale I was painting in, this worked out to be from the ferrule of my long-handled brush to the tip of the handle. Now if I wanted to know where to place his hand or any other part of his body on the canvas, I could simply work out how many key measures it would take me to go from the top of his head to the area in question. Say, it might be 2.5 times my key measure. Transferring this to my painting, I measure 2.5 times the length of my brush from ferrule to top of the handle.

Keep your eyes open

Instead of waiting until you've got a blank canvas in front of you, try to look at things continuously, and use your powers of observation to work out how you might tackle them in a painting. On a bright, sunny, sky-blue day, look at leaves and you will see that their top surfaces are often the brightest part of them – almost white where the sun hits them. Then look at the underneath of these sun-lit leaves to see the vibrant green of light going through them; how, in shadow areas, the tops of the leaves can pick up the blue of the sky and not look green at all. You should think, 'How do I paint them? I need to tackle that blue.'

Paint what you see, don't paint what you know, if you want to be realistic. Paint leaves bright red, if you want to. That's the nice thing about painting – there's no-one to tell you that you're wrong. You can always say, 'That's what I meant to do!'

PAINTING PEOPLE

If you're painting people, try and look for the lopsidedness of them. Everybody is lopsided to one degree or another. Just look at yourself in the mirror and the way you smile. I smile off to the left-hand side, and my whole face is geared to that. The crease round the left side of my mouth is much fiercer than on the other side, and one eyebrow is raised slightly higher than the other.

Some people's eyes are actually on different levels. More amazing facts – your hand, from wrist to fingertips, is the same size as your face from chin to hairline, and your foot is the same size as from your inner elbow to your wrist. If you measure on the side of someone's face, you'll see that from the outside corner of the eye to underneath the chin is the same as from the outside corner of the eye to the back of the ear.

Self Portrait with Glasses

Oil on canvas
63 x 46 cm (25 x 18 in)

After doing *My Self Portrait* for television (see page 40), I wondered if I could do another self portrait in the style of Van Gogh using different tones of reds and yellows, rather than mixing any whites in with the face. So I put in a bluey-green background (which shows through the finished picture in places) and just used various yellows, oranges and reds to do the face. Once again, I used hatching on the shirt, face, hair and shadows, and I tried to make a swirly pattern to give the flat, boring background some interest. The actual background was a dark brown wall, so this colour is much more exciting. I feel the other self portrait was better because it was done under such pressure but I think this one works well, too.

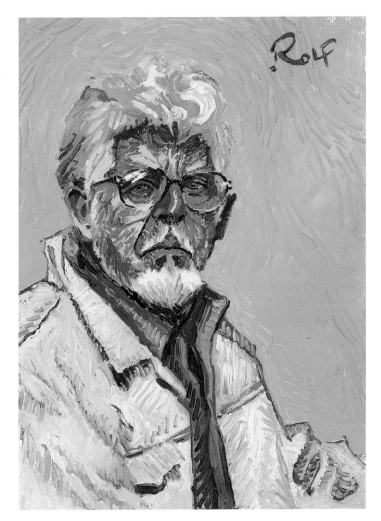

Mrs Mundy

Oil on canvas paper on board
56 x 46 cm (22 x 18 in)

Mrs Mundy was a model at art school, and I did this painting in one wonderful session in 1954. I put in the basic picture in dark brown and then put the other colours on top. You can see the brown showing through the dress. I picked four or five light pinkish tones for the face and the neck, and the joy of it came when I sneaked some of the green of the background above her head under her chin so it looks like reflected light from the chunky beads she's wearing.

I love the satiny material of the dress, the two brassy tones of the hair and the little light yellowy tones on the dark shadows.

Man Leaning

Pen and ink on scrap paper
38 x 28 cm (15 x 11 in)

I did this pen-and-ink sketch before filming one of my TV shows. I needed reference for a painting I was doing of an Aussie bar, and asked one of the dancers to pose so I could see what happened to his body and his jacket when he stood in that cross-legged position. I've no idea why I didn't draw the rest of his arm on the other side!

Girl on Beach (detail)

This detail from my painting *Love at Low Tide*, on page 68, was done very simply in a few brushstrokes. I just wanted to give an impression of the young girl's shape. I love the tiny triangle of flesh colour where her foot is – little things like this really help to bring a picture to life.

Runners (detail)

When tackling action in a painting, guard against the fact that one's brain always tends to even things up towards the vertical or towards the horizontal. If someone is running, you need to keep the angles that their body creates, as in this detail from my painting *Running into the Dusk* on page 74.

SKETCHING

Another couple of golden rules for painting – keep your sketchbook handy and always keep your sketches. You never know when they will come in useful, either for information or to give you the inspiration to paint a picture. I love sketching and still hope to do paintings from sketches I did decades ago!

Trees and Graffiti

Pen and ink plus felt tip
25 x 40 cm (10 x 16 in)

Driving towards Windsor, I passed this big housing estate and saw all these wonderful trees. I just loved it – some day I'm going to do something with this sketch. You can see by the graffiti how old it is!

Woman with Pram

Pen and ink on cartridge paper
35 x 25 cm (14 x 10 in)

This information sketch took about 30 minutes. The woman was walking the pram past the corrugated iron outside a London building due for demolition. I sketched her before she got away, then put in the key architectural features.

Coventry Cathedral

Felt tip on scrap paper
25 x 40 cm (10 x 16 in)

This sketch of the cathedral gave me
information for a television programme
I did in Coventry in the 1970s.

Church and Cedar

Felt pens on card
19 x 40 cm (7 x 16 in)

I love this one, sketched on the way to
London. It's just a representation of trees
in winter; no leaves but all that ivy growing
around them in a mass of dark green
against the view of the church. Look at
that wonderful cedar of Lebanon.

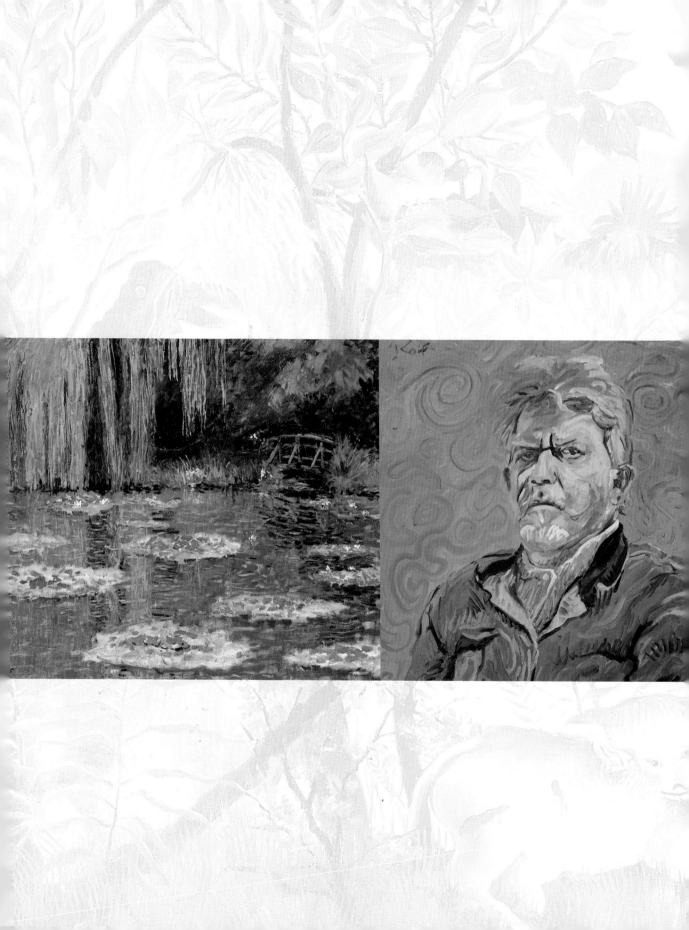

CLOSE ENCOUNTERS
OF THE ARTISTIC KIND

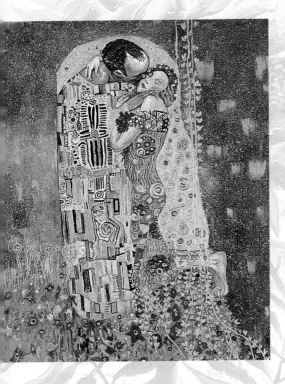

It was a great joy for me to follow in the footsteps of eight incredible artists during the filming of *Rolf on Art* for television. I made some fascinating discoveries about the varied and very colourful lives of these men, as well as gaining hands-on insight into the way they worked. My brief was to try to create paintings and – in the case of Rodin – sculptures, inspired by their best-known works of art. As much as possible, I used the same techniques they would have used. I hope you enjoy reading about my artistic journey. I certainly enjoyed every step of it.

CLAUDE MONET

Because people thought that Monet's canvases were too audacious and often looked unfinished, he had difficulty selling them in the early part of his career. Now he is arguably the best-loved of all the Impressionists. *Haystacks, Last Rays of the Sun*, not seen in public since 1895, sold at Sotheby's in 2000 for an amazing £9.2 million, proving the enduring quality of his genius.

Claude Monet was born in Paris in 1840. His family moved to Le Havre and, as a teenager, he quickly gained a reputation as a caricaturist of local figures. There he met the landscape artist Eugène Boudin, who took him outdoors and showed him what it was like to paint landscape from nature. 'It was as if a veil had suddenly been torn from my eyes,' Monet said. 'I understood. I grasped what painting was capable of being.'

His father was only slowly reconciled to having a son pursuing such a frivolous career, and was further upset when, at the age of 25, Claude took a mistress and had an illegitimate child by her. This was scandalous behaviour in the 1860s, although Monet and Camille did later marry.

The Impressionist movement

Monet studied for a year in Paris with a like-minded group of artists, including Renoir and Sisley. What was so innovative about the work of these young men was

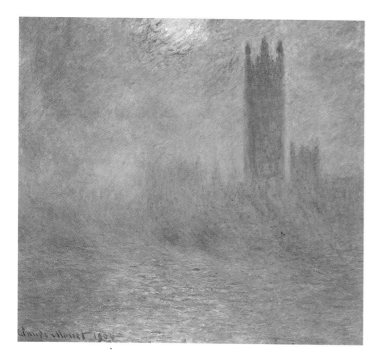

◄ **Houses of Parliament, London, Sun Breaking through the Fog**
Claude Monet, 1904
Oil on canvas
81 x 92 cm (32 x 36 in)
Musée d'Orsay, Paris

the brightness of the colours that they were starting to use, the application onto the canvas of pure colours that mimicked the brightness of nature and of daylight itself.

During the 1860s, Monet had already begun to use methods that were to become his trademarks: painting directly from nature and using quick brushstrokes to record the overall effect rather than the tiny detail. He often worked outside with Renoir, and both began to develop theories regarding the effects of light and colour, completely eliminating black to show shadows and instead using contrasts of other juxtaposed colours.

Although all of these artists, later known as the Impressionists, were already meeting regularly by the end of the 1860s, they were not to hold an exhibition of their work until 1874. It was Monet's painting in this exhibition, *Impression: Sunrise* (1872), that led to the group's name.

Series paintings

Monet is perhaps best known for painting the same subject over and over again. He spent the winter of 1875 painting snow scenes in Argenteuil, and painted 12 views of St Lazare station in 1877.

After Camille's death in 1879, he began to travel widely around France, painting sequences of pictures, very often of dramatic coastal weather effects, and in the 1890s, he worked hard on several series of paintings depicting haystacks,

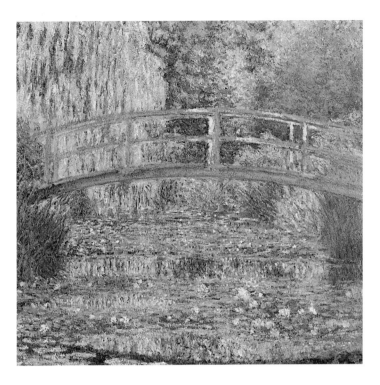

poplars, and Rouen Cathedral. Later, in 1900, when Monet was 60 years old, he embarked on his two most ambitious projects, the series depicting the Thames (producing almost 100 canvases on this theme by 1904) and the series depicting his beloved water garden at Giverny.

In his final years, Monet was plagued by failing eyesight, due to cataracts, which made it difficult for him to discern blues, greens and violets. In 1923, although terrified by the prospect, he underwent surgery, after which he was compelled to wear thick protective glasses. Two years later, his eyesight had dramatically improved, and he continued to paint until his death in 1926.

▲ **The Water Lily Pond, Harmony in Green**
Claude Monet, 1899
Oil on canvas
89 x 93.5 cm (35 x 37 in)
Musée d'Orsay, Paris

The Water Lily Pond, Giverny

materials

- OIL PAINT
 Cobalt Violet,
 Lemon Yellow,
 Cerulean Blue,
 French Ultramarine,
 Burnt Umber,
 Titanium White,
 Viridian,
 Emerald Green
- BRUSHES
 A selection of
 large, medium,
 small and rigger
 brushes
- SURFACE
 Canvas,
 66 x 102 cm
 (26 x 40 in)

Painting in Monet's garden at Giverny was wonderful, but quite a challenge. I know Monet loved water, but the rain we experienced while filming for television was something else! However, I am happy with my finished painting, particularly the way the purple background colour zings through and brightens up the green. I think it works.

Altering nature

When Monet settled in Giverny, one of the things he did was to excavate a large hole, divert the local stream into it, and create a pond, which he stocked with exotic plants, mainly water lilies. As the plants came to maturity, he started to focus almost exclusively on the lily pond in his garden.

He was fascinated by the surface of the water and the extraordinary effects that the changing light had on the reflections in it. Although he was normally dedicated to capturing natural things as they occurred, he did cheat a bit here – he had created the pond himself, so that he would have it on his doorstep and could paint it at any time.

The Impressionists were trying to get away from time-consuming studio-based paintings; they wanted to capture a scene outdoors quickly, as it happened, with all the changing light. Monet threw himself into this and came up with a pretty neat system. He kept a dozen different canvases in different stages beside him as he was working. He would paint one scene but, when the lighting situation changed, would lift that canvas from his easel, take the next one out of his rack, and get on with that.

Monet painted this view at least 24 times in all seasons and at all times of the day, sometimes starting at 3.30 in the morning. For my painting, I used the same colours as him and attempted to use some of his techniques, adapted to my own style.

I began by covering the canvas with rough brushstrokes of Cobalt Violet to kill the white. Almost everything in the scene was green, so a purply background, the opposite to green on the colour wheel, would give vibrancy to the finished picture. I put the willows in with fine downward strokes using my tiny rigger.

Upon reflection...

I established Monet's bridge with bright green to show out against the dark background but I found it quite hard to get the exact colour green, and even more difficult to paint its reflection in the water.

'Everyone discusses my art and pretends to understand, as if it were necessary to understand, when it is simply necessary to love.'

CLAUDE MONET

▶ THE WATER LILIES

After lifting the lily pad shapes out of the background with a turpsy rag, I sloshed colour on to indicate the shape of each clump, then added sky reflections on the green of the leaves, and some flowers.

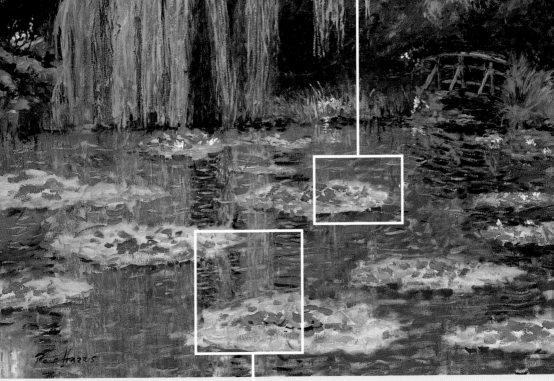

◀ BRUSHWORK

Monet loved his long-handled brushes, and so do I. He didn't use a lot of linseed oil and liked to use dry paint to get the reflections in the water

materials
- OIL PAINT
 French Ultramarine,
 Cerulean Blue,
 Cobalt Blue,
 Alizarin Crimson,
 Yellow Ochre,
 Cadmium Yellow,
 Titanium White
- BRUSHES
 A selection of large,
 medium, small and
 rigger brushes
- SURFACE
 Canvas,
 50 x 75 cm
 (20 x 30 in)

The Houses of Parliament

Monet loved painting things in different light conditions, and didn't just stay in France to do this – he travelled to Holland, Venice and even to London. The River Thames, in particular, drew him like a magnet.

The Houses of Parliament had just been built and Monet loved the architecture and the reflections it cast in the water. He did almost 100 canvases based around the river, and would often paint from the window of his room at the Savoy Hotel. He loved the London fog and the mist, and the way he could get all sorts of unexpected colours in his paintings. When I did this painting for television, we were moored on a boat in the middle of the Thames and I found out just how difficult it is to paint, bobbing around on a busy river,

something Monet himself did frequently in Paris, on the River Seine.

Changing light

I started by putting in a complementary reddish colour to the blues I would be using in my painting. To be even truer to Monet's approach, we were working at the end of the day to capture the changing light and, to keep up with nature, you have to paint quickly.

This was easier said than done! As I was painting, the light changed drastically. A wonderful cloud came over, as black as thunder, but as I was painting it, the sky suddenly brightened and the cloud went away. So I tried to get an impression of what had been there a minute before, with the setting sun just catching the edge of the cloud as it began to shift.

Monet's colours

I'm very pleased with this painting and I really enjoyed working in Monet's colours. I think the deep reds of the buildings contrast nicely against the sunlit pinky-yellow and bluey-purple cloud and the sky colours.

'The Thames was all gold. God, it was beautiful; so fine that I began working in a frenzy, following the sun and its reflections on the water.'

CLAUDE MONET

◀ SPRING GREENS

Here I have tried to give an impression of the spring green of leaves starting to appear on the winter branches. I did this with wet, feathery brushstrokes over the top of what was already there.

▶ MOVING WATER

I put in the reflections of the towers using horizontal brushstrokes, to show the moving water on such a cloudy, heavy day.

EDGAR DEGAS

I must say that, as a painter, I am completely in awe of Edgar Degas. His paintings look totally spontaneous and fresh and his pastels look as if he's done them in a fine dash of excitement. But, in fact, he said you should draw and paint things a hundred times – a thousand times even – until you get them as you want them.

▼ **After the Bath, Woman Drying Herself**
Edgar Degas, 1888-92
Pastel on paper mounted on cardboard
103.8 x 98.4 cm (41 x 39 in)
The National Gallery, London

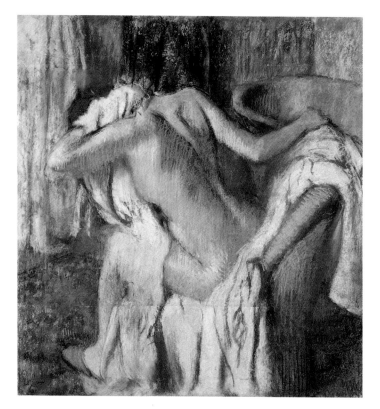

Degas was born in Paris in 1834 into a rich and cultivated background; his father knew lots of artists and people in the art world, and his social standing often gave him access to new ideas and challenges. He began painting historical subjects, but quickly realized this wasn't for him. Degas had a strong sense of his own taste and what he considered was worthwhile. People thought he was rather cold and voyeuristic, particularly in the way he painted working-class figures – women ironing, women mending clothes, prostitutes – a whole spectrum of modern city life.

A brilliant draughtsman

Degas' mother died when he 13, and he became used to his own company. He did have a few very close friends, and, as long as they didn't cross him, he was immensely loyal, but it was easy for things to go wrong and then they were cast out forever. Referred to by his contemporaries – Renoir, Gauguin and later on by Picasso – as the greatest draughtsman of them all, Degas preferred to think of himself as a Realist, and was constantly critical of the Impressionists, although he

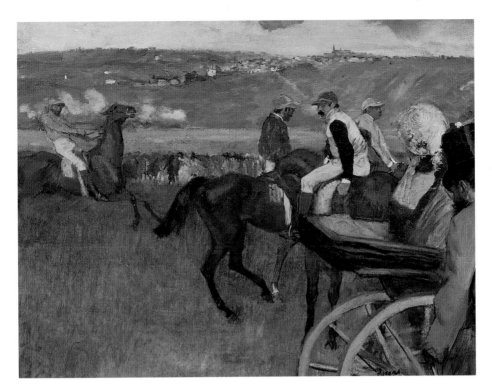

did exhibit regularly with the group, and met frequently with its members.

All through his life, Degas concentrated on four main subjects: horses, women bathing, women working, and ballerinas. His paintings and his pastels seem to capture the moment in a very unobtrusive way. Yet, unlike his contemporaries, he never painted outside his studio. Instead, he took his sketchpad and made hundreds of drawings wherever he went.

In later works, Degas moves beyond the very clear lines and draughtsmanship of his earlier paintings, and develops an extraordinary improvised freedom of handling. You still do get things that look like lines but they weave in and out and create these extraordinary sort of skins across the surface of the sheet of paper, producing all types of different effects.

Degas was a very modern artist in the sense that his works were never finished until he decided to stop working on them, and it might be 20 years after starting a work that he finally decided it was completed. He would even take back paintings that had been finished, signed and sold, and work on them again – some owners used to chain their pictures to the wall to prevent him removing them!

Using photographs

As well as working from sketches, Degas occasionally used the relatively new medium of photography to help his art. His pictures are carefully composed, and look for all the world as if he has captured figures in mid-movement.

At a relatively early age, he began to lose his eyesight, and in about 1908, nine years before his death, he finally laid down his brushes. By this time, Degas' art had become widely sought-after and throughout the world it has continued to grow in value over the years.

After the Bath

It's hard to imagine now but, back in Degas' time, people were shocked by some of his paintings because they seemed to capture such private moments. However, although the women in his paintings may look as though they've been chanced upon by the watchful eye of the artist, in reality they were models posed by him in his empty studio in a completely controlled environment. We think Degas must have added all the curtains, carpets and domestic details later, working from his sketchbooks.

To try to understand more about his working methods, I set up my easel in a London studio to recreate one of his most famous works of a woman bathing, *After the Bath*.

Degas was known to be an experimental artist, and I enjoyed trying out new techniques to emulate his style for television. I attempted to do my own version of a Degas bather, hoping that I could achieve in my pastel some of the intimacy that Degas managed.

I was very happy with my finished pastel and really enjoyed doing it – I just wish I was half the draughtsman that Degas was.

Bodywork

I started with the model's back. Next, I put in the towel, then the fingers, and then I added the shadow. I wish I'd studied more anatomy when I went to art school. What a pain in the neck I was at the time – because I couldn't do it, I thought, 'I won't bother with this.' Now I really wish I had!

Dry brushwork

Degas experimented with all sorts of techniques. He often put some pastel on the paper, then smoothed it and spread it with a dry brush.

The model's hair

I love the bright orange colour of Liz's hair. I think it must have been really difficult to be a Degas model. He wanted to convey an impression of someone glimpsed through a partially open doorway, when the subject was totally unaware that the artist was drawing. In fact, he would probably have posed them in that same position for quite a long time.

'No art is less spontaneous than mine. What I do is the result of reflection and study of the great masters; of inspiration, spontaneity, temperament, I know nothing.'

EDGAR DEGAS

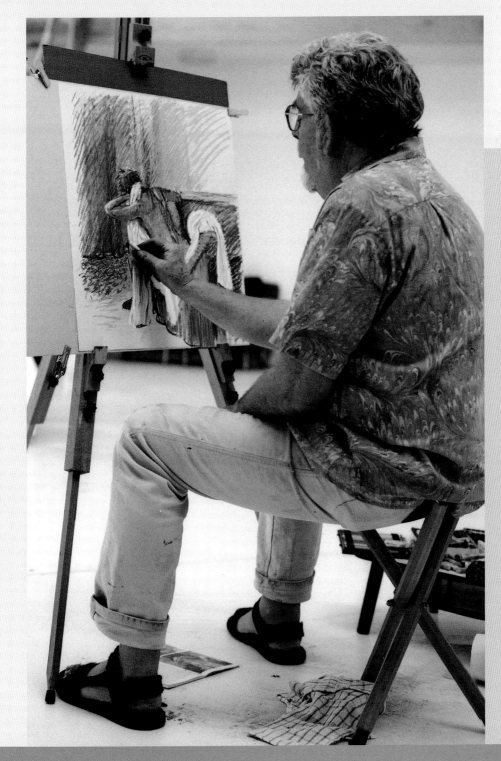

- PASTEL
 A selection of flesh tones, oranges, reds, greens, blues, browns and yellows
- BRUSHES
 A selection of large, medium, small and rigger brushes
- SURFACE
 Pastel paper, 60 x 45 cm (24 x 18 in)

materials

- OIL PAINT
 French Ultramarine,
 Cobalt Blue,
 Cadmium Yellow,
 Lemon Yellow,
 Alizarin Crimson,
 Cadmium Red
- BRUSHES
 A selection of large,
 medium, small and
 rigger brushes
- SURFACE
 Canvas,
 46 x 62 cm
 (18 x 25 in)

The Jockey

Degas always enjoyed drawing horses – and, by 1860, Paris had its very own race course at Longchamps.

Colourful images

Although he was totally uninterested in the races themselves, Degas loved to capture what went on beforehand: the colourful images of fidgeting jockeys and horses, just as with ballerinas he loved nothing better than to get a picture of a girl scratching her back or adjusting her tights.

For the *Rolf on Art* television series, I went to the races at Windsor to try to capture the atmosphere as Degas would have done by sketching and taking photographs. It was quite a challenge, because I had only a few hours to paint and, unlike Degas, didn't have the luxury of retreating to a quiet studio!

As a horse and jockey went by with their groom, my Polaroid couldn't keep up with some of the movement, and I photographed the moment with the groom as a total blur. I'd also missed the horse's nose and I cursed. Then I remembered that the Impressionists, influenced by Japanese woodcuts, often had the picture frame cutting halfway through a figure, challenging the tradition in which the whole story had to be contained within the picture. Instead of trying to fix it up so that the groom didn't look blurry, I grabbed the moment and painted the blur. I'm quite pleased with the way my painting worked, although there are things I could go back and try to improve – I know Degas would have!

You don't need detail

This apparently casual, slightly blurred painting is really what I understand impressionism to be. You don't need to put in everything – if you step well back, it seems as if all the tiny detail is there. You can see the face of the groom so clearly from a distance that you could pick him out in a police line-up!

'One must do the same subject over again ten times, a hundred times. In art nothing must resemble an accident, not even movement.'

EDGAR DEGAS

◄ THE BLURRED BUSHES
I was thrilled to bits with the loose, impressionistic way that I painted the jockey – the blurred bushes behind him add to the impression of movement.

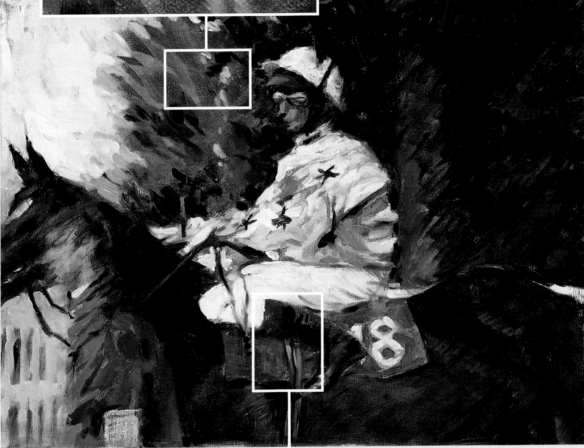

► THE RED BOOTS
A little girl reminded me to put the red into the jockey's boots – it was a delightful moment and the colour really zings out of the picture. I just put some paint on my thumb and dabbed it on – something that Degas often did in his paintings.

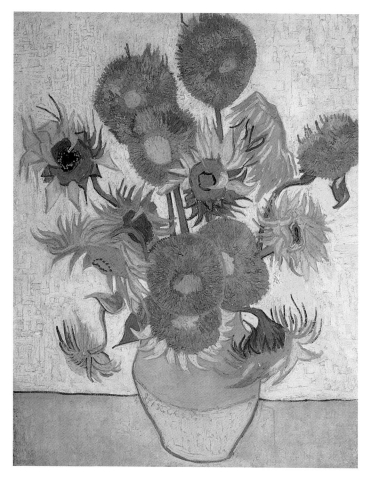

VINCENT VAN GOGH

People were ill at ease with Van Gogh's approach to painting during his lifetime. When I was about 11, a new teacher showed us a book of Van Gogh's paintings – it was the first time I had ever seen them. In my supreme arrogance as the best artist in the class, I looked at Van Gogh's work and said, 'He can't draw. He can't draw at all. It's all wrong.' Now I wish I could paint like him.

▼ **Sunflowers**
Vincent Van Gogh, 1889
Oil on canvas
95 x 73 cm (38 x 29 in)
Van Gogh Museum,
Amsterdam

Van Gogh was born in Holland in 1853, the son of a vicar. He wanted to become a preacher and started doing theological studies. When he was 25, he went to Belgium, working and preaching in the poorest areas. It was at that time that he began to think of himself as an artist, finding that he could express himself better through sketching than through preaching.

The vibrancy of Paris

When he was 33, he went to Paris at the urging of his brother Theo, who was an art dealer there. Theo felt that exciting things were happening in the Parisian art world which could benefit Vincent.

He was right. Vincent was soon painting in bright, vibrant, contrasting colours, using small, sharply accented brushstrokes, all of which he'd picked up from the works of the Impressionists. He realized that for him colour was the real means of expression.

However, it wasn't long before the bohemian life of Montmartre began to pall,

and Van Gogh moved south to Arles. Here he found what he was looking for – strong sunlight, bright blue skies, and the rich greens and yellows of the countryside. These colours fitted perfectly with his vivid new palette. He rented a house and invited Paul Gauguin to join him in what he hoped would be the 'Studio of the South'. It was like a fresh new start and Van Gogh was inspired by everything around him. He decorated the house and painted colourful canvases to welcome his artist friend.

Gauguin and Van Gogh

When Gauguin arrived, there was a brief period of intense work and sharing of ideas, and a very creative time for both of them, but things began to sour. One gets the feeling that Van Gogh hero-worshipped Gauguin, and his puppy-like devotion, coupled with his untidiness, must have started to grate on Gauguin's nerves.

For whatever reason, Gauguin decided to leave, and this disappointment – this apparent destruction of his 'Studio of the South' dream – drove Van Gogh to slash off his left ear lobe with a razor. The piece of his ear, wrapped in cloth, he gave as a 'present' to a local woman he admired, and this irrational behaviour stunned the people of Arles. They forced him to get hospital treatment for himself. Vincent spent a year in an asylum near St Rémy-de-Provence. He was there of his own free will and the hospital came to represent a safe haven for him. Sadly, he continued to have relapses

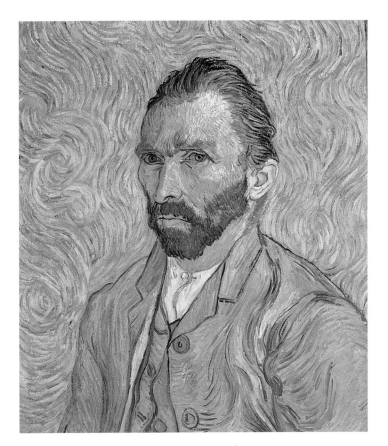

▲ **Self Portrait**
Vincent Van Gogh, 1889
Oil on canvas
65 x 54.5 cm (26 x 22 in)
Musée d'Orsay, Paris

but, in between these, he painted many of his most vivid works, including this particularly stunning self portrait.

Auvers-sur-Oise

Once he was well enough, Vincent moved to Auvers-sur-Oise, just outside Paris, and, full of inspiration, he painted and painted. In this incredible period, he produced one finished painting every day for 73 days! But he was feeling completely on his own again. He wrote to Theo of troubled skies, sadness and extreme loneliness.

At the end of July 1890, Van Gogh borrowed a revolver, went out into a wheatfield and shot himself in the stomach. He managed to get back to his room but died two days later, his brother Theo at his bedside. He was just 37 years old.

The Church at Auvers

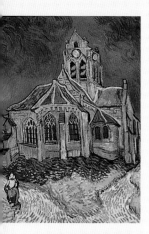

▲ The Church at Auvers
Vincent Van Gogh, 1890
Oil on canvas
94 x 74.5 cm (37 x 29 in)
Musée d'Orsay, Paris

I did three paintings for television in the style of Van Gogh. The first was of the Church at Auvers – one of my favourite Van Gogh paintings. I used the same colours as him and, hopefully, similar techniques. I wasn't trying to copy his painting but, by doing my own interpretation, I wanted to get some kind of insight into the way he worked.

Van Gogh wasn't a perfect draughtsman like Degas; in his earlier paintings he used to sketch in all the perspective lines with pencil on the canvas (experts have discovered this by x-raying some of his work). However, in his later paintings, he would just dilute French Ultramarine and sketch the picture in with the brush, and so I began by mixing turpentine with French Ultramarine and laying this in roughly. Next, I added some fierce sky to the painting.

Strangely, it seems as if Van Gogh stood in different positions to draw the church – the three different sections don't appear to have been drawn from the same position at all.

Bright new colours

The 19th century saw huge advances in chemistry, which was wonderful for artists. New pigments were invented and artists like Van Gogh made grateful use of the brilliant new colours. Sadly, these weren't tried and tested like traditional ones, and many were very unstable. In 1888, Van Gogh wrote to his brother Theo complaining about the problem, saying he had to apply new pigments more thickly to compensate for the changes that took place.

The lost pink path

In his painting *The Church at Auvers*, the pink lines that Van Gogh painted on the path have faded and virtually disappeared from view. The final touch to my own painting was to restore some of the dark pink lost in Vincent's original work. I think he would have liked that.

'It is better to be high-spirited even though one makes more mistakes, than to be narrow-minded and all too prudent.'

VINCENT VAN GOGH

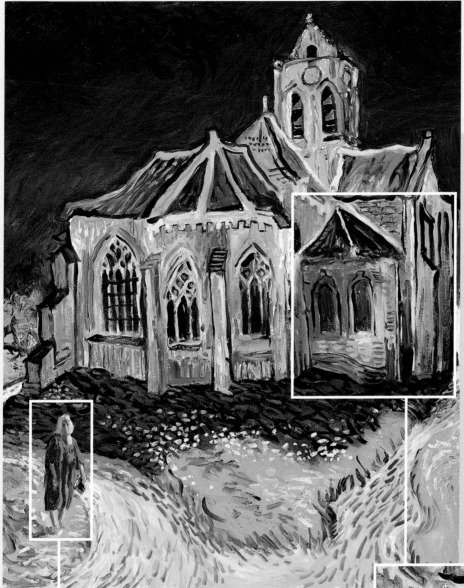

materials
- OIL PAINT
 Cobalt Blue,
 French Ultramarine,
 Vermillion,
 Yellow Ochre,
 Cadmium Yellow,
 Lemon Yellow,
 Rose Madder,
 Titanium White
- BRUSHES
 A selection of large,
 medium, small and
 rigger brushes
- SURFACE
 Canvas,
 127 x 97 cm
 (50 x 38 in)

▶ VIBRANT COLOURS

The real colour of the church is very dull but, in Van Gogh's style, I used vibrant colours and lots of wet-on-wet paint to get the sort of effects he achieved.

◀ THE WOMAN'S FIGURE

I asked my wife Alwen to stand where the peasant woman had been in Vincent's painting.

- OIL PAINT
 Cobalt Violet,
 French Ultramarine,
 Alizarin Crimson,
 Cobalt Blue,
 Lemon Yellow,
 Yellow Ochre,
 Cadmium Red,
 Titanium White
- BRUSHES
 A selection of
 large, medium,
 small and rigger
 brushes
- SURFACE
 Canvas,
 128 x 95 cm
 (50 x 38 in)

My Self Portrait

Even when Van Gogh was hard up in Paris, he had a mirror – so he was never short of a model. It is often said that he looks miserable and tortured in his portraits. Well, believe me, it is extremely hard to sit for two and a half hours laughing and smiling at your own image while you paint yourself. The smile starts to crack at the edges and eventually falls off with a crash!

Glasses off...

Maybe you're wondering why I'm not wearing my glasses for this self portrait? Well, I wanted to be able to see exactly what my eyes were doing and, with glasses on, you get reflections and you can never see the eyes properly. So I've left my glasses off.

Background colour

My approach when I've got a blank canvas is to kill the white right at the start. Because the colours Van Gogh used in his portrait were all blues and greens, apart from the light on the side of the face, I began by covering my canvas with red paint. This would act as a complementary colour to the blues and greens and I hoped that, by leaving a little bit of red showing through, my portrait would have vibrancy and life.

When in doubt, rub out!

While checking and measuring, I realized that the ear on the right was wrongly positioned. Still, one of the great things about oil painting is that you can wipe out a mistake with a cloth and start again. It's an awful thing to do and makes you feel absolutely sick inside at the time, but unless you do it, the thing is going to be wrong for ever and a day. So that's exactly what I did. I wiped it off and started again.

The finished portrait

Van Gogh himself said that knowing yourself isn't easy. Believe me, painting yourself isn't any easier! I've done quite a few self portraits in my time, but I'm happiest with this one, thrilled to bits that I tackled it in this way, and the best thing is that I had the nerve to actually take that ear out and re-do it. I hope you like the end result.

'And my aim in my life is to make pictures and drawings, as many and as well as I can; then, at the end of my life, I hope to pass away, looking back with love and tender regret, and thinking, "Oh, the pictures I might have made!"'

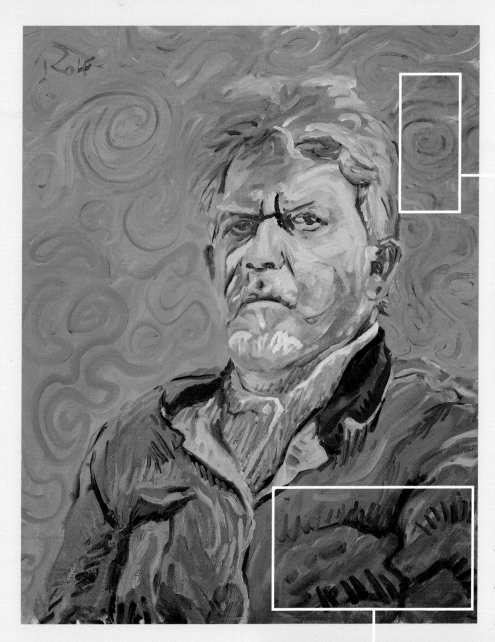

▲ SWIRLING BACKGROUNDS

Vincent liked to take an area that was flat and bring it to life by making patterns and spirals to enhance his picture. I just love them and they are great to do.

▶ SHADOW AREAS

Instead of mixing up shadow colours, Van Gogh often did his shaded areas with thick brushstrokes of a darker colour. This gives terrific strength and unity to his paintings, and I was thrilled to find that I could make this technique work in my picture. Here, instead of mixing up a mid-green shadow colour, I used dark lines of hatching on my jacket. I also used lighter hatching strokes to lighten up areas.

Sunflowers

materials

- OIL PAINT
 Yellow Ochre,
 Cadmium Yellow,
 Lemon Yellow,
 Viridian,
 French Ultramarine,
 Cadmium Red,
 Titanium White
- BRUSHES
 A selection of
 large, medium,
 small and rigger
 brushes
- SURFACE
 Canvas,
 127 x 96 cm
 (50 x 38 in)

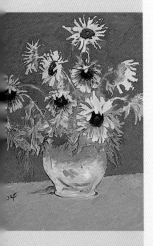

Sunflowers are a really lovely subject. It's no wonder that Gauguin asked if he could keep one of the sunflower canvases that Vincent painted.

Many of the Impressionists did their paintings as an impression from start to finish – you can imagine them seeing the image as a blurred photograph and then refining it. However, when Van Gogh worked on his paintings of sunflowers, he apparently began with the flowers and put the background in last. I tried, but I had real difficulty doing this – it's not my usual approach and the background looked stodgy.

Out of the darkness

This was the very first painting of the TV series and I thought I'd completely blown it! I was painting with three gifted amateurs and, although I was supposed to be the 'expert', their paintings looked way better than mine!

We were in a busy London flower market and I decided to make my background a uniform, dark colour so the sunflowers would stand out against it brilliantly. Unfortunately, the end result looked funeral (see my original painting, left) and

I realized that Van Gogh's background had been a similar vibrant yellow to his sunflowers – in fact, exactly the way the other three had painted their pictures.

Putting things right

After I'd finished the painting, I did the old Impressionist trick of taking it home to do some more work on it later. As soon as my original dark background colour was dry, I painted over it. The nice thing about oils is that you can let something dry and then you can completely cover it with a new colour. So I crosshatched a new background in with some gutsy yellows and it made all the difference in the world.

Outlining the pot

Normally, with an impressionistic painting, I wouldn't put an edge in if I couldn't see it. I'd smudge it off into the background or paint the background up to it. But I was painting in the style of Vincent, so I put in a strong outline for the pot and the edge of the table, and I think it really does seem to say 'Van Gogh'! I also copied his plaiting or weaving pattern to enliven a boring piece of foreground, as well as on the background.

'It is not the language of painters but the language of nature which one should listen to . . . The feeling for the things themselves, for reality, is more important than the feeling for pictures.'

VINCENT VAN GOGH

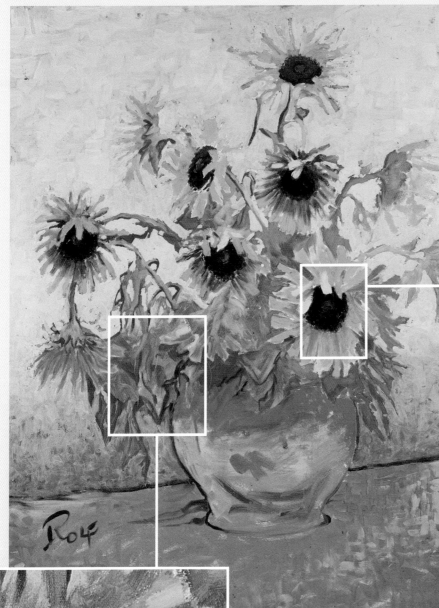

▲ PROMINENT PETALS

I found it very pleasing to put in the slightly shaded areas of the petals first and then sit some of the foreground petals over them really brightly. This made them stand out obviously in front of the other petals, giving a three-dimensional quality to the flowers.

◄ LEAF COLOURS

I tried to organize my leaf colours into four or five green tones but feel now that they look rather uniform. Van Gogh would have isolated separate bits and had them much darker than others, pinpointing areas and drawing your eye to them with strong colour.

PAUL GAUGUIN

As a young man, when I first saw Paul Gauguin's early work, I was fascinated and, I must say, slightly shocked to see patches of brilliant colour that didn't seem to relate to the rest of the natural colours in his landscapes. Now I realize that he was obviously happy to give free reign to his imagination, and I revel in his paintings.

▼ **Martinique Landscape**
Paul Gauguin, 1887
Oil on canvas
115 x 88.5 cm (45 x 35 in)
National Gallery of Scotland

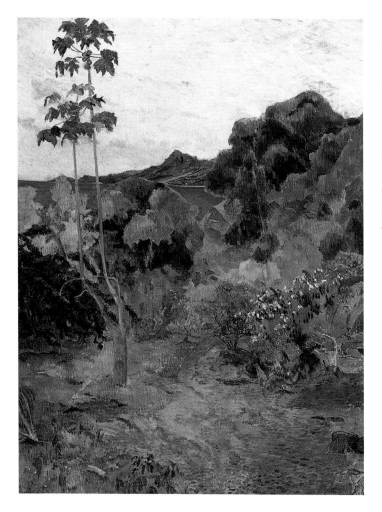

Gauguin was born in Paris in 1848, but spent his early years in Peru. After serving in the Merchant Marines, he became a stockbroker in Paris, where he married and had five children. He was a Sunday painter until he met the Impressionists. He was so influenced by them that, when there was a stockmarket crash, he became a full-time artist, and started travelling increasingly without his wife. Gauguin certainly didn't abandon the family at first, but his impulse to create art was such that he realized he had to follow it.

In pursuit of a dream

Finally, in his forties, Gauguin packed up and went about as far away as he could go. He travelled halfway round the world, in pursuit of his dream of living the simple life in the South Sea islands.

While Gauguin was in Tahiti, he continued to write to his wife, but she clearly felt thoroughly betrayed by him. The bond that kept them together was the children, and in his letters he keeps

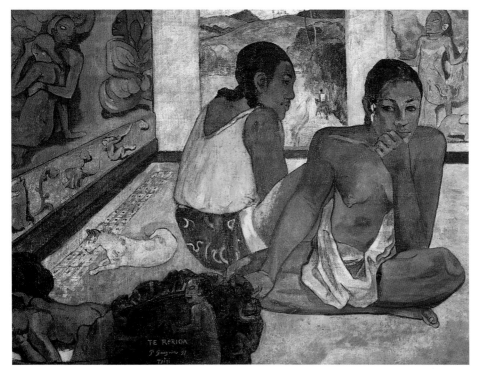

◀ **The Dream**
Paul Gauguin, 1897
Oil on canvas
95.1 x 130.2 cm (38 x 52 in)
Courtauld Institute Gallery,
Somerset House,
London

emphasizing what his new life is all about and that must have hurt her constantly. But, in his defence, this exotic world was where he created his most famous paintings.

Scandalous behaviour

It was also where he created a reputation for himself back home in France. Following local custom, he established relationships with several young Tahitian women and, of course, he painted them.

When he sent his work back to Paris to sell, everyone – including his family – was scandalized. There's been a lot of discussion about how one should read Gauguin's experiences and the way he lived with the local people in Tahiti. I think he went there because he saw it as a place where he could be free to make art in the way he wanted, using his fertile imagination but also working with live models who treated nudity as totally natural.

Like many of his contemporaries, Gauguin was unable to make a living from his painting, and eventually had to sell his Impressionist collection. He held an auction of his own work in 1895, but 47 of 74 pictures remained unsold. In 1901, he left Tahiti and settled in the Marquesas Islands, where he continued to work through poverty and illness (he was suffering from syphilis). His dream was coming to an end. He died poor and lonely there in 1903.

Influencing art

Gauguin's work is more Symbolist than Impressionist, and he certainly influenced the subsequent 20th-century movements of Expressionism and Primitivism. Although never commercially successful, he wasn't a humble man. Always convinced of his talent, he wrote to his wife, 'I am a great artist and I know it. It is because I am that I have endured such suffering.'

- **OIL PAINT**
 French Ultramarine,
 Cerulean Blue,
 Cadmium Orange,
 Vermillion,
 Yellow Ochre,
 Titanium White,
 Lemon Yellow,
 Cadmium Yellow,
 Alizarin Crimson,
 Black
- **BRUSHES**
 A selection of
 large, medium,
 small and rigger
 brushes
- **SURFACE**
 Coarse-weave
 canvas,
 128 x 95 cm
 (50 x 38 in)

Rolf's Dream

Reality certainly wasn't sacred to Gauguin – it was merely a starting point. His painting *The Dream* is a deliberately mysterious collage of images that were important to him. Like him, I'm definitely a bit of a hoarder and so, from my memory and all my bits and pieces, I decided to create my own version of *The Dream*, hoping to get an idea of how Gauguin created his.

I used Gauguin's colours and the kind of open-weave canvas he would have used. Gauguin applied his paint very thinly, partly to create a special effect, but also because paint was very expensive and he didn't have much money.

This subject was so different for me – I normally paint exactly what I see in front of me. I like the way that what we think is carpet in the painting becomes grass, and moves into the picture of my childhood memory.

Part of my dream

Woven into my dream had to be my strong ties with the Aboriginal people. The elder and his son were part of a huge mural that I did in Canberra, depicting the life of Australia. I definitely had to get a few didgeridoos in there somewhere, too!

Gauguin's kangaroo

I put a kangaroo in because Gauguin had one in his – now *that* really does seem to be quite symbolic! I've also put in Rabbit, one of our cats – he loves sitting in that Haida Indian cedarwood box. I also included our two dogs, Cadge and Summer.

Memories

Myaluen, the Aboriginal for 'home by water', was the house that my dad built for us in Western Australia. The central top part of the painting depicts a little bit of my life there. That's me, as a kid, running down the steps to the water. I really had a magical time as a youngster.

Jake the Peg

The colourful boots in the right-hand corner were specially painted for me by a lovely Aboriginal lady from my home town – she even painted three so that they would fit on Jake the Peg!

'It is the eye of ignorance that assigns a fixed and unchangeable colour to every object; beware of this stumbling block.'

PAUL GAUGUIN

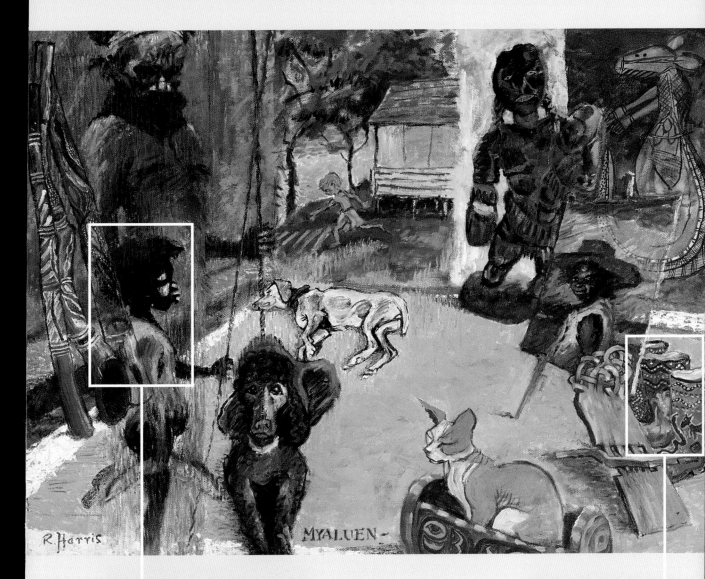

R. Harris

MYALUEN-

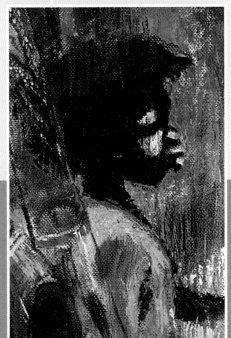

◀ BRILLIANT LIGHT
The Aboriginal boy was inspired by an early photograph I had seen. I love the hugely dark head, with brilliant light on the face to indicate the features.

▶ THE PATTERN
When I tried to paint the intricate pattern on the welly boots with wet-on-wet paint, I realized just how complex the original work was. Mine is a very simplified version.

materials

- OIL PAINT
 Cerulean Blue,
 Cobalt Blue,
 French Ultramarine,
 Cadmium Orange,
 Yellow Ochre,
 Vermillion,
 Titanium White
- BRUSHES
 A selection of
 large, medium,
 small and rigger
 brushes
- SURFACE
 Canvas,
 76 x 61 cm
 (30 x 24 in)

Tropical Vegetation

I didn't have far to go in my search for the tropics – the largest greenhouse in the world is in Cornwall. There, at the Eden Project, Gauguin-style, I had to leave out all the geodesic glass dome above and just paint the jungle view. Believe me, as I worked for the cameras in those hot, humid conditions, with the gutsy colours Gauguin would have used, I could almost imagine I *was* painting in the tropics!

Gauguin's Garden of Eden was by no means perfect. The islands had been Westernized already before he arrived but he didn't let this spoil things. His painting *Martinique Landscape* has the whole town of St Pierre missing. Gauguin decided that the town spoilt the view, so he just left it out.

I painted my picture with much thicker paint than I gather Gauguin would have used, but I think it's quite a nice sort of Gauguin-like attempt at ignoring man-made structures and trying to get a glimpse of paradise.

Could do better

The tall tree was the most important feature. I can't believe I didn't fix up that thick branch at the top. Branches should get gradually thinner as they grow but that one on the top left looks like it's a trunk. I could have mixed a bit of white cloud colour and thinned the branch down with it – maybe I will some day!

Man-made lake

The gutsy, dark mango tree in my painting was actually there but the whole vista at the top right of the painting, looking down on what appears to be a lake, was made up by me to create the impression of being high up and looking down to water going off between blue hills. I think it works pretty well.

'A critic in my house sees some paintings. Greatly perturbed, he asks for my drawings. My drawings? Never! They are my letters, my secrets.'

PAUL GAUGUIN

▼ VERTICAL BRUSHSTROKES

Gauguin used a lot of vertical brushstrokes and liked fierce colour. Although the path at the Eden Project was light brown, I made it a bright, Gauguin-like orange colour and had it snaking off around the house into the distance, inviting you to wander away through the vegetation.

◀ LAST-MINUTE THING

This blossom was almost an afterthought. The two bushes in the picture didn't have any, but there were others off to the left that did. I used my artist's licence to add a few blooms.

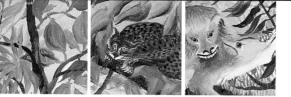

HENRI ROUSSEAU

Rousseau had no formal art training, came from a poor family and didn't start painting until he was in his early forties. During his lifetime, his work was laughed at as much as celebrated, but he was truly unique and was to become a key figure in art history, leading the way for modern art.

Henri Rousseau was born in the small town of Laval in western France in 1844. His father was declared bankrupt in 1851, and this meant the young Henri was unable to pursue his dream of attending art school. At the age of 19, he joined up for five years of military service in France, and would later embellish his military exploits, claiming to friends that he had fought in Mexico.

He married, moved to Paris and got a low-paid job in the Customs Office, earning him the slightly ridiculing nickname 'Le Douanier' (the Customs Officer). However, throughout his daily mundane existence, he continued to develop his love of painting.

Rousseau's first efforts at painting, shown at the Salon des Indépendents in 1886, were seen as amusing, innocent and decorative but, five years later, his *Tropical Storm with a Tiger: Surprise!* won him the admiration of fellow artists. Over the years, he was to paint another 26 jungle scenes, all on huge canvases.

Untrained eye

In 1893, Rousseau took early retirement to devote his life to painting. His untrained eye gave him a freshness of vision, and his vivid imagination gave rise to some fantastic scenes.

Picasso adored Rousseau's work and, in 1908, threw a banquet in his honour. It was the first time Rousseau really felt accepted as an artist – finally, his work was respected. But he was never able to make a successful living from painting and, when he died in 1910, he was buried in a pauper's grave. It was only much later that his paintings began to receive universal critical acclaim.

The Hungry Lion
Henri Rousseau, 1905
Oil on canvas
201.5 x 301.5 cm
(80 x 120 in)
Private collection, Basel

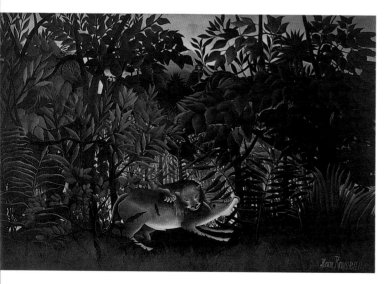

My Self Portrait

Rousseau's *Myself: Portrait Landscape* is full of things that interested him, and he places himself in the centre of everything, standing on the Port Saint-Nicolas in front of the Ile Saint-Louis in Paris. In the spirit of patriotism, he includes the two emblems of France's technical achievement – the hot-air balloon and the Eiffel Tower.

He did this painting when he was 46 years old – four years before his voluntary retirement – and wanted to show that he was a proper artist. On his lapel, he is wearing a medal he'd been presented with, and he has a typical French artist's beret on his head.

Rousseau updated this painting over the years as things happened in his life – on the palette he wrote his wife's name

Clémence. After her death, he added the name of his second wife, Joséphine.

A London landscape

My version has a backdrop of the Tower of London and Tower Bridge, with the river Thames between them – and, of course, I just had to include some Beefeaters!

I now wish I'd put the Tower and the bridge in browns rather than in realistic colours, and made the clouds more like paper cut-outs. It would have looked more like Rousseau's portrait landscape.

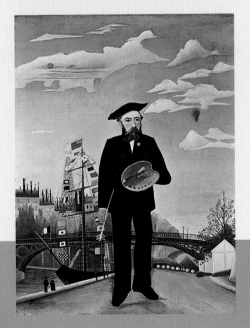

Myself: Portrait Landscape (from L'Ile St-Louis)
Henri Rousseau, 1890
Oil on canvas, 146 x 113 cm (56 x 45 in)
National Gallery, Prague

materials

- **ACRYLIC PAINT**
 Vermillion, French Ultramarine, Black, Cadmium Yellow, Titanium White, Yellow Ochre, Cobalt Blue, Cerulean Blue, Alizarin Crimson
- **BRUSHES**
 A selection of large, medium, small and rigger brushes
- **SURFACE**
 Canvas, 102 x 76 cm (40 x 30 in)

The Hungry Lion

Few people of his time seemed to understand Rousseau's art, but one thing is for sure – once seen, his work is never forgotten. Picasso, Gauguin and Matisse loved the simplicity he was able to achieve.

Jungle scenes

Rousseau is most famous for his exotic jungle scenes – strong colours, strange animals and precisely painted, dense foliage, and yet he found almost all his inspiration in the Jardin des Plantes, the botanical gardens of Paris. He would go there regularly to absorb the atmosphere and feed his imagination, sketching the plants and all the different leaves he found as accurately as he could, before heading back to his studio to paint.

For the television series, I was to attempt my own version of Rousseau's *The Hungry Lion*, hoping to get a better idea of just how he created his paintings. Incidentally, Rousseau's full title for his painting was: *The hungry lion pounces on the antelope, and tears it apart; the panther timidly waits for the moment when it, too, can have its share. Birds of prey have each torn a bit of flesh from atop the poor animal, which has shed a tear.*

First, with my sketchbook, I retraced Rousseau's steps to the Jardin des Plantes and, while trying to copy his painting, marvelled at the variety of plants, leaf shapes and colours that were his inspiration. In my subsequent painting, I used the kind of techniques that he used and the colours that were available to him.

Since time was short, I had to paint wet-on-wet, and the white, staring eyes of my panther really suffered – I couldn't get a clean white line around the eyes, and it was really difficult to put in detail. Of course, Rousseau painted on a much larger canvas than mine – so his panther was at least twice the size of mine – and he would often spend three months on one painting, so that every layer was left to dry before he applied the next. How he could bear to wait that long, I really don't know!

The ghostly figure

I enjoyed copying Rousseau's wonderfully sinister animal, which is hiding in the foliage on the left – it looks like a cross between an ape and a bird. You can vaguely see its furry legs at the bottom and its long, furry arm grabbing a branch.

'Nothing makes me so happy as to observe nature and paint what I see. Just imagine, when I go out into the countryside and see the sun and the green and everything flowering, I say to myself, "Yes, indeed, all that belongs to me!"'

HENRI ROUSSEAU

▶ PALE SKY

I would have liked to have got more density behind the main figures, instead of having pale sky showing through where the jungle should be. I couldn't – time was against me.

◀ MULTIPLE BRUSHSTROKES

I did the foreground grass last and taped five long-bristled, fine brushes together, so that I could make five parallel marks as I painted.

HENRI DE TOULOUSE-LAUTREC

Henri de Toulouse-Lautrec is most famous for his paintings of the cancan dancers at the Moulin Rouge – and, of course, for being very short! This remarkable character was a nobleman by birth and, despite his short stature, was to become a towering figure of late 19th-century art.

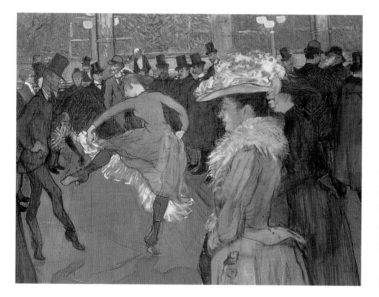

The Dance at the Moulin Rouge
Henri de Toulouse-Lautrec, 1889-90
Oil on canvas
116 x 150 cm (45 x 60 in)
Philadelphia Museum of Art, Pennsylvania

Henri de Toulouse-Lautrec's brief life can be characterized by an amazing artistic output and too much absinthe. The walking stick he relied on was hollowed out by a friend to hold alcohol and a miniature glass!

He was born an aristocrat in Albi, France, in 1864, the son and heir of the handsome and eccentric Comte Alphonse-Charles de Toulouse-Lautrec, and last in line of a family that dated back 1000 years. Henri was avidly painting and drawing by the time he was 10. Sadly, at different times in his teens, he broke both his legs and, because of a hereditary bone disease, they stopped growing. By adulthood, he was just 1.50 m (4 ft 11 in) tall.

Life at the Moulin Rouge

He studied in Paris and, by 1885, had a studio in Montmartre, the centre of cabaret entertainment. He became a well-known regular in the cafés and bars, sketching the characters and entertainers, and was a frequent visitor to the Moulin Rouge.

The bohemian lifestyle really punished him. He was drinking heavily, sketching every night until dawn, and then painting every day. By 1899, when he collapsed and was confined to a sanatorium, he had completely destroyed his health. He recovered briefly, but suffered a relapse and, in 1901, cared for by his mother, he died at his family home, the Château de Malromé. Toulouse-Lautrec was just 37. Since then his paintings and posters – particularly those depicting the Moulin Rouge – have become world-famous, and he is remembered as one of the most colourful personalities in the history of art.

Rolf's poster

Many of Toulouse-Lautrec's lithographs were commissioned by the performers themselves for posters or theatre billboards. Of course, he knew these celebrities personally.

Apparently, the director of Les Ambassadeurs hated the poster of the poet Aristide Bruant, with his trademark hat, scarf, cloak and stick, and refused to hang it. He only put it up when Bruant threatened not to perform!

The lithographic process, discovered in 1799, relies on the fact that water and grease repel one another. The artist draws directly onto a flat stone surface with a greasy medium which soaks into the stone and attracts the printing ink. The rest of the stone is washed with water, which repels the ink.

Rolf on Art

My lithographic poster advertising *Rolf on Art* was an almost exact replica of the Bruant poster, the only differences being the text, the 'Rolf' face, and the paint brush in the hand instead of the walking stick. Creating and printing that poster gave me some of the most fulfilling moments of my life.

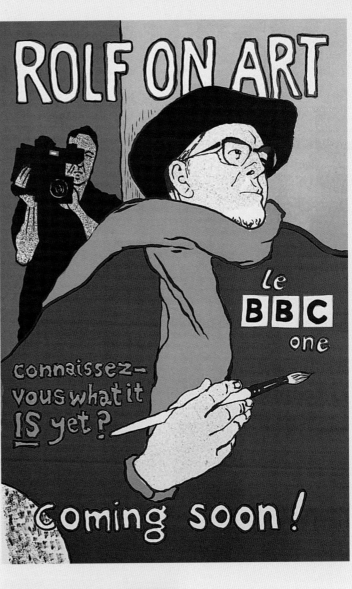

Rolf on Art poster
Rolf Harris
Lithograph in purple, orange and red Indian ink
73 x 47 cm (29 x 19 in)

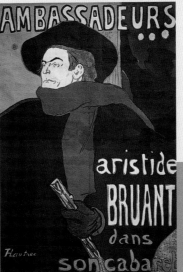

Ambassadeurs: Aristide Bruant
Henri de Toulouse-Lautrec, 1892
Lithograph in six colours (poster)
127 x 92 cm (50 x 36 in)
National Library, Paris

Cancan at the Moulin Rouge

materials

- **OIL PAINT**
 Titanium White,
 Yellow Ochre,
 Viridian, Burnt
 Umber, French
 Ultramarine,
 Cobalt Blue,
 Vermillion,
 Lemon Yellow
- **BRUSHES**
 A selection of
 large, medium,
 small and rigger
 brushes
- **SURFACE**
 Canvas,
 75 x 100 cm
 (30 x 40 in)

Lautrec was a superb draughtsman – he was able to use a few swift, short lines to capture the atmosphere and to convey a scene. He didn't like posed models, and preferred to sketch real action (like the cancan) which gave movement to his subsequent paintings.

Because he was such a prolific painter, he adopted the *peinture à l'essence* technique, also used by Degas, which involved putting paint on a piece of blotting paper to draw out the oil, then mixing the paint with turpentine. This meant it dried quicker, so he could layer paint without delay. It also dried matt, and this is what gives his oil paintings their chalky, pastel-like appearance.

He also often painted on cardboard – its texture and the way he could leave areas uncovered suited his quick, sketchy way of working.

Friends and family

Lautrec often put his friends and family in his paintings – his cousin Gabriel and his father are in the background of *The Dance at the Moulin Rouge* on page 54. His cancan dancer was, of course, *'La Goulue'* (the Glutton), so called because she regularly drained everyone's drinks in the club. His great friend Jane Avril – another famous dancer – is the figure in pink on the right of his picture. She was the only performer he ever painted 'off duty'.

Background information

Before I could start my own painting for television, I needed some background reference material. I began by sitting at a pavement café in Montmartre, sketching suitable characters to put in my audience. That night, we went to the Moulin Rouge to see the current show – particularly the cancan.

Back in the studio, I used my sketches and the show brochure to paint from. I was particularly captivated by the energetic splits of the central dancer and the male dancer in mid-air, as well as the wonderful foursome holding their heels high above their heads. I also loved the vibrant costumes in red, white and blue, the colours of the French flag.

Incidentally, the lady on the right was our French interpreter. I also couldn't resist adding a self portrait in the corner of the picture – Lautrec often made cameo appearances in his own pictures!

'Love is a disease which fills you with a desire to be desired.'

HENRI DE TOULOUSE-LAUTREC

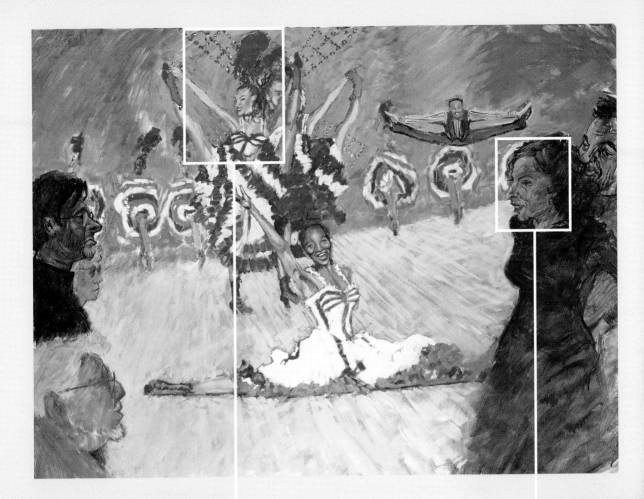

◀ THE WINDMILL
I used a little Lemon Yellow and Titanium White to pinpoint the lights on the sails of the windmill.

▶ REPEATING COLOUR
I wanted the audience to be in brown tones to thrust them into the foreground, so I used the same Burnt Umber I'd used on the outline of my central figure.

GUSTAV KLIMT

Gustav Klimt was a controversial figure in his time. His work was constantly criticized for being too sensual and erotic, and people didn't understand his symbolism. Today, his paintings stand out as some of the most important ever to come out of Austria.

Klimt founded the Vienna Secession, a group of painters, architects and designers who were part of the Art Nouveau movement, which was sweeping through Europe. He was born in Baumgarten, near Vienna in 1862. His father was a gold engraver but the family were poor. At the age of 14, Klimt entered the Vienna Public Art School and his artistic talents were quickly spotted. In fact, he received his first commissions while still at school.

He first made his name as a painter-decorator, forming the Company of Artists with his brother Ernst and fellow art student Franz Matsch. They worked on many government commissions for theatres, churches and museums.

When his brother and father died in 1893, Klimt moved into his own studio and turned to easel painting. Soon posing for a portrait by Gustav Klimt was all the rage amongst society women.

His companion and muse

Klimt lived with his mother and his two unmarried sisters all his life and supported them financially. He had many lovers but his regular companion was Emilie Floge, the beautiful sister of his sister-in-law. She was a clothes designer and had a shop called the Casa Piccola, for which Klimt designed clothes occasionally. Emilie acted as Klimt's muse, and often helped him with his work.

Klimt was a fitness fanatic and, for many years, lived in fear of having a stroke. In January 1918, he did suffer a massive stroke, which left him paralyzed down his right side. Unable to paint any longer, he lost the will to live and died from pneumonia less than a month later.

▼ **The Kiss**
Gustav Klimt, 1907-8
Oil, silver and gold leaf
on canvas
180 x 180 cm (71 x 71 in)
Belvedere Gallery, Vienna

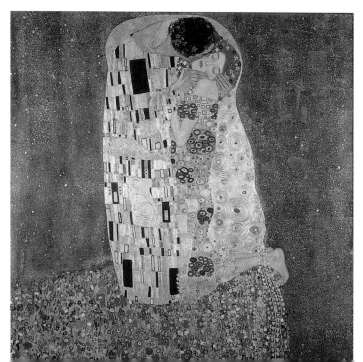

The Kiss

During his life, Klimt travelled extensively around Europe by train. After visiting Italy and seeing the mosaics at Ravenna, he was inspired to use more and more gold in his pictures, and to use mosaics for a dramatic effect.

For television, I was filmed as I sketched two models meeting and embracing at Waterloo Station in London. Then I used my drawings and photographs to do my version of *The Kiss*, one of Klimt's most famous images. Compared to the wall-dominating size of the original, my painting was tiny, and this meant I had to use my smallest brushes to create all the detail. Klimt used a lot of gold leaf, but I used gold paint – a first for me – and soon found that I had to wait for any gold areas to dry completely before I could add patterns in another colour.

Painting with a toothbrush

I used some Australian aboriginal motifs in my decoration, but by far the most exciting moment of the painting was spraying a fine stipple of my gold paint onto the background – using a toothbrush!

materials
- ACRYLIC PAINT
 Cobalt Violet,
 French Ultramarine,
 Cobalt Blue,
 Cerulean Blue,
 Lemon Yellow,
 Naples Yellow,
 Vermillion, Carmine,
 Titanium White,
 Gold, Renaissance
 Gold, Chrome Green
- BRUSHES
 A selection of large,
 medium, small and
 rigger brushes
- SURFACE
 Canvas,
 76 x 76 cm
 (30 x 30 in)

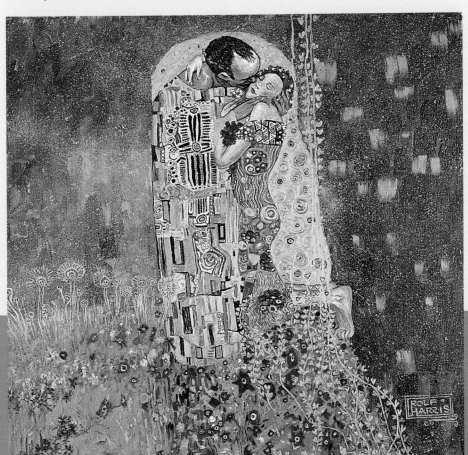

Golden Jubilee Frieze

The *Golden Jubilee Frieze* was painted with scenery paint (liquid emulsion paint in cans) in Yellow Ochre, Red, Royal Blue, Prussian Blue, White and Black, and acrylic paint in Gold and Renaissance Gold. Decoration included gold leaf, mother-of-pearl buttons, glass, diamanté and mosaic tiles, stuck on with UVA glue. A selection of decorator's and small, round bristle brushes were used. The surface was three marine ply panels, each 185 x 120 cm (72 x 48 in).

One of Klimt's most famous murals is the *Beethoven Frieze*. For TV, I decided to paint a frieze, inspired by Klimt's work, for the Queen's Golden Jubilee. Mine (small by Klimt's standards) would depict the Queen and Prince Philip riding in the Gold State Coach to St Paul's Cathedral, against a futuristic view of the streets of London, as seen by the cheering crowds. The finished work – completed in just one day – would hang at Southwark Underground Station, on London's Jubilee Line.

Fast work...

What a day it was! With the help of two design students, I quickly covered the three huge white surfaces with Klimt-like squares and oblongs of different colours, graduating from dark to light as they reached the sky. After that, I flicked handfuls of water over the wet and drying paint. The resultant vertical

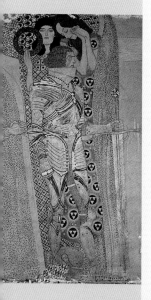

◀ **Beethoven Frieze (detail)**
Gustav Klimt, 1902
Casein (a milk-based paint) on plaster, layered cane, stucco and gold overlay, ornamented with semi-precious stones, pieces of glass and mother-of-pearl, charcoal, graphite, pastels.
34 m (113 ft) long
Secession Building, Vienna

trickles down through the colours gave a wonderfully unifying effect.

Then the serious fun began, painting the procession and adding all the intricate decoration. We almost worked ourselves to a glorious standstill, but produced, I hope, a fitting tribute to the Golden Jubilee.

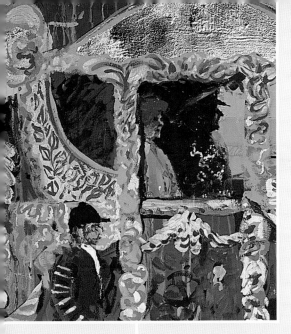

◄ THE ROYAL COUPLE
I did a fairly blurry, impressionistic image for the Queen and Prince Philip, but I think they are quite recognizable from a distance.

► THE HORSES' LEGS
I would have welcomed a bit more knowledge of how horses' legs work. All we had to go on were Polaroid photos of the video on a television screen. In those, all the horses' legs were a total blur.

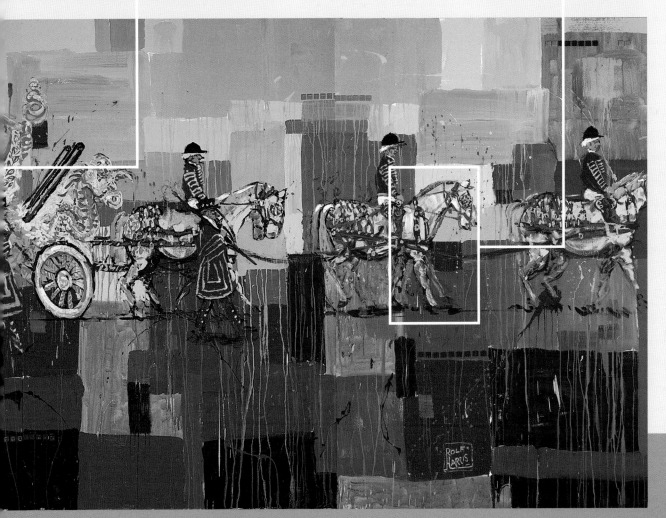

AUGUSTE RODIN

Say 'sculpture' and the name Rodin immediately springs to mind. So when the BBC asked if I would like to attempt some sculpture in his style, I was delighted, because he had always been a hero of mine...delighted but, at the same time, terrified. I'd never tackled sculpture before!

Auguste Rodin was born in 1840, the son of a Parisian police official. At the age of 14, he went to a special school for art and mathematics but, although he worked hard, and won prizes for drawing, his sculpture let him down. Three times he was refused admission to the prestigious Ecole des Beaux-Arts. To make a living, he took a job as a decorative stonemason. Although the work was often boring and tedious, the next four years honed his observational and artistic skills.

In 1864, he met Rose Beuret, who became his life-long companion, the mother of his child, and a model for his early artistic work.

Rodin visited Italy in 1876, and was so impressed by the work of Michelangelo that he was inspired to complete a freestanding sculpture, *The Bronze Age*, that he'd almost given up on. The result was so life-like that critics accused him of making a cast from a live model. The ensuing controversy made Rodin famous almost overnight, and thrust him into a satisfying period of great creativity. The French State bought the sculpture, and also commissioned him to create huge bronze doors called *The Gates of Hell* for the Museum of Decorative Art. This was still unfinished at his death in 1917, but sections of it had become the basis for some of his most famous works, including *The Kiss* and *The Thinker*.

Rodin the businessman

Rodin became not only the most famous living sculptor in the world, but one of the best businessmen. His sculptures, cast in plaster, were used as displays to secure commissions for works in marble and bronze. Once he hit on a popular image, he'd have many duplicate versions made, and selling them helped pay his many bills.

Rodin was a very intense and charismatic artist. He had a great many affairs, but Rose stayed with him throughout, and he finally married her when he was 77. Within a year, they were both dead, and are buried beneath his most famous statue, *The Thinker.*

▼ **The Thinker**
Auguste Rodin, 1881
Bronze, 76 cm (30 in) high
Rodin Museum, Paris

Bindi's Hands

Rodin is seen as the father of modern sculpture. He brought in numerous innovations, one being the idea of creating a new form in sculpture – the fragment as a finished piece of art. Seen as shocking at the time, sculptures like his two hands almost intertwined, known as *The Cathedral*, are now hailed as some of his most important work. He took the fashion away from completely smooth and stylized modelling, to sculptures that unashamedly showed the marks of the sculptor's hands and tools in the clay.

When I attempted my version of Rodin's *Cathedral* for television, I asked my daughter Bindi, who is also an artist and sculptor, to model her right hand for me. I was thrilled when she felt able to offer constructive criticism during the process.

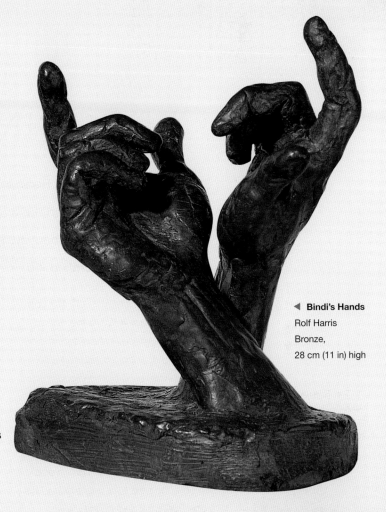

◀ **Bindi's Hands**
Rolf Harris
Bronze,
28 cm (11 in) high

Full of life

I tried to emulate Rodin by leaving the marks of my fingers and thumbs and modelling tools very obviously in the clay. To me, this was almost like doing an impressionistic painting, leaving the work full of life rather than smoothing it out to a boring uniformity. As in Rodin's sculpture, we decided to cast two identical copies of Bindi's right hand, and have them facing one another on a solid base. The really exciting part was positioning the two wax versions of the hand the way Rodin must have done, knowing they were going to be cast in bronze. When the bronze sculpture finally came out of the mould, I was thrilled, almost beyond words!

'Nothing is a waste of time if you use the experience wisely.'
AUGUSTE RODIN

▲ **The Cathedral**
Auguste Rodin, 1907
Bronze, 65 cm (26 in) high
Rodin Museum, Paris

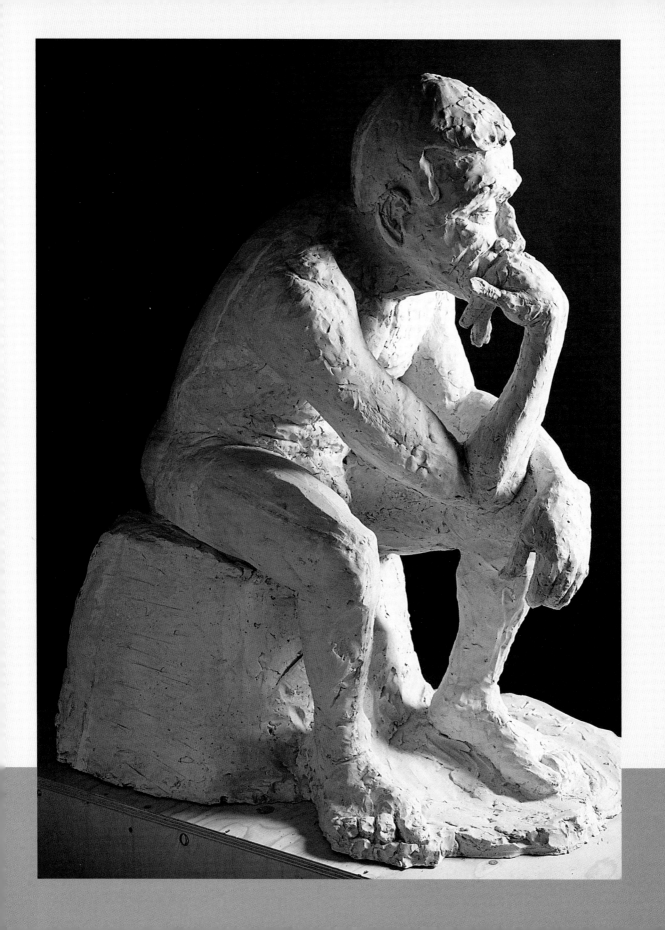

Rolf's Thinker

Today, there are many versions of Rodin's sculpture *The Thinker* in existence, but the best known are in the gardens of the Rodin Museum in Paris, and on the grave of Auguste and Rose at Meudon. It is probably the most famous of Rodin's works.

It was modelled to occupy the summit of *The Gates of Hell*, representing Dante meditating on his creation. There, it is just 71.5 cm (28 in) high! It was enlarged in 1902 and exhibited in 1904, arousing strong reactions from the press.

The Thinker was erected in front of the Panthéon in Paris in 1906 (although it was removed in 1922 because it became a socialist symbol at a time of political unrest). That cast is the one that can now be seen at the Rodin Museum.

Sculpture lessons

To work on my version of *The Thinker* for television, we went to Rodin's country home at Meudon, which is just outside Paris, and were able to set up in what had been his conservatory and use his original sculpture stands. I started on the real thing, working from a live model.

It was very nearly a disaster, as I took over an hour to make a most appalling armature to support my sculpture. (This is the wire 'skeleton' that you build your clay on.) I persevered and finally, four hours later, achieved a surprisingly satisfying and, I think, fairly reasonable attempt at my *Thinker*.

Scaling up

The next step was to transport the sculpture back to London to get it scaled up to a metre in height, and have it cast in plaster of Paris. I'll draw a curtain over the scaling-up process, because I honestly didn't understand how the expert did it! All I can say is that I returned two days later to find a metre-high clay reproduction of my tiny *maquette*.

I was amazed at how many things looked wrong when I saw the enlargement, but was able to make corrections in the clay, based on photos I had taken of the model posing at Meudon. I'm very happy with my alterations to the head, but wish I'd had time to do more to the legs and body. However – mistakes and all – I think the final plaster cast of my sculpture looks stunning, and I can't wait to do some more.

◄ **The Thinker**
Rolf Harris
Plaster
1 m (39 in) high

'The artist must create a spark before he can make a fire and, before art is born, the artist must be ready to be consumed by the fire of his own creation.'

AUGUSTE RODIN

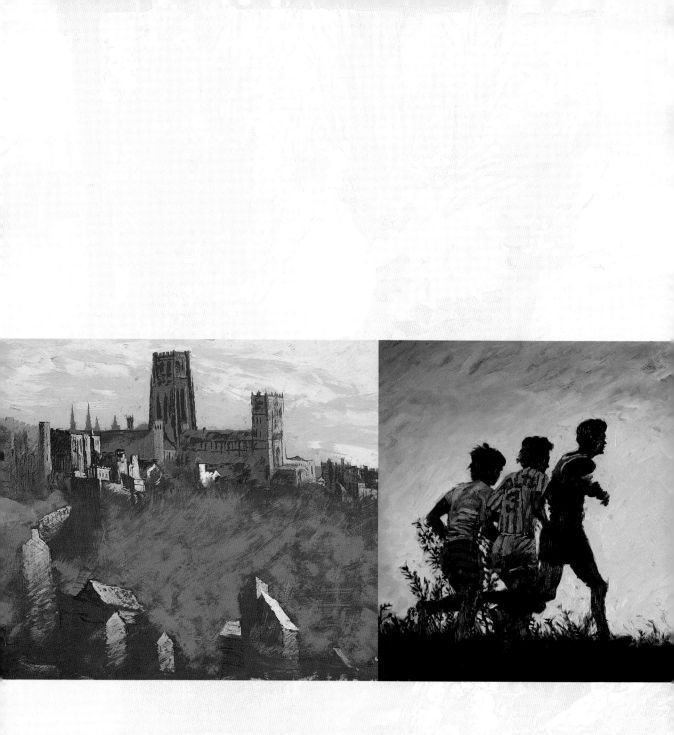

STEP INTO
MY STUDIO

It's always fascinating to see how other artists work and, even if your approach is different to theirs, it can inspire you to do some new work of your own. Many of my paintings for the television series were done on location, so it was a real treat to spend time back in my studio. With the exception of my portrait of *The Didgeridoo Player*, the following paintings were all done from enlargements of prized photographs I have taken over the years. I hope you enjoy a step-by-step look at how I painted them.

Love at Low Tide

I took this photograph on holiday at Ile Saint-Michel in France. It was mid-afternoon and the two figures in the shallow water on the otherwise deserted beach made a very romantic, atmospheric picture. With all the different blues needed, this was going to be a challenge!

1 I had previously painted my board with a mix of Cadmium Red, Cadmium Yellow and a tiny bit of Titanium White to create a pastel orange – the opposite colour to the all-pervading blue of my picture – and left this to dry. Then I mixed up the colours I needed before beginning, starting with the horizon.

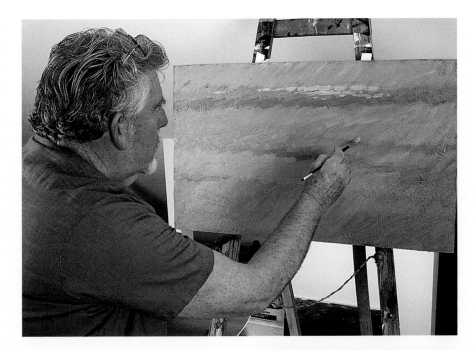

materials

- OIL PAINT
 Cadmium Red,
 Cadmium Yellow,
 Titanium White,
 Cerulean Blue,
 French Ultramarine
- BRUSHES
 A selection of large,
 medium, small and
 rigger brushes
- SURFACE
 Hardboard,
 45 x 76 cm
 (18 x 30 in)

2 I built up the picture loosely, using a mixture of 'scumbling' (see page 95) and free diagonal brushstrokes.

3 You can see how I used different tones of blue and green to create the colour and texture of the wet, sandy expanse of beach.

4 I used a slightly darker blue sky colour here, taking my brush upwards in diagonal strokes from the horizon. This helped to unify the painting and gave the impression of light coming down from the sky.

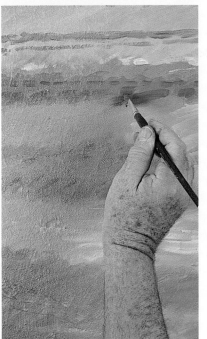

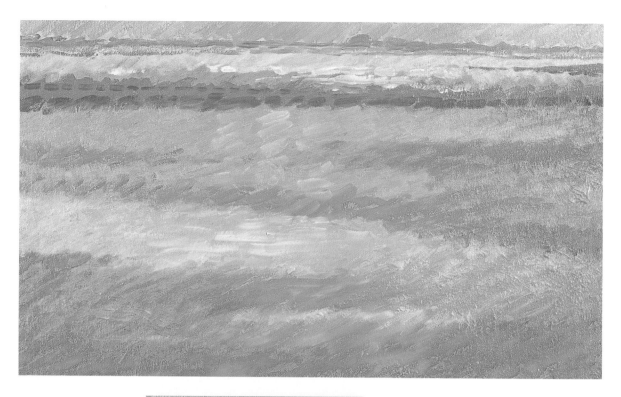

5 With the beach painted in, it would soon be time to start putting in the young couple. Their figures were really tiny, so I would need to change to my rigger brushes, which would also be useful for the next two steps.

6 I'd already put a sunlit area towards the top of the painting, but I decided to make it even brighter so it would really zing out in the picture.

7 I also put in some lovely, dark horizontal strokes to add detail, using the lightest of touches and still with my rigger brush.

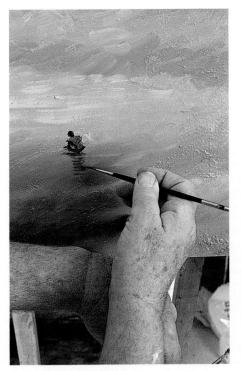

8 I put in the young man first – his body was done very simply in two shades of blue. When painting his reflection with small, horizontal brushstrokes, I used my other knuckle to help steady my painting hand.

9 Next I established the girl, again using very few brushstrokes – I just wanted to give an impression of her sensual little shape. I used my white paint as thickly as possible to make her shirt stand out really brightly, and I love the way the flesh colour really created the shapes of arms and legs. I added a little bit of the same flesh colour to pick out the young man's arm.

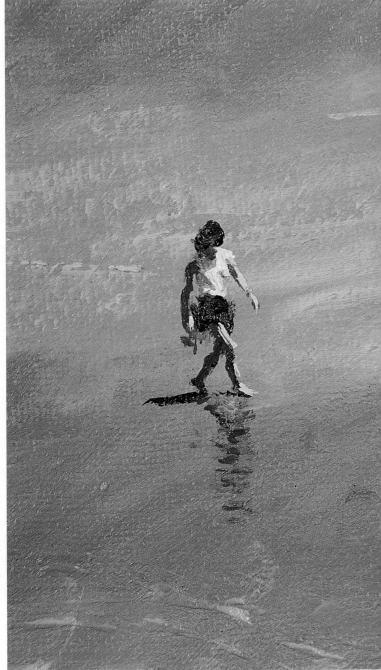

▶ Rolf's techniques and tips

Notice how I've used a separate brush for each colour in my painting. It's so that my colours remain pure and don't get mixed up with each other, plus if I need to repeat a colour that has already been used, that exact colour is always there mixed on the palette, waiting for me.

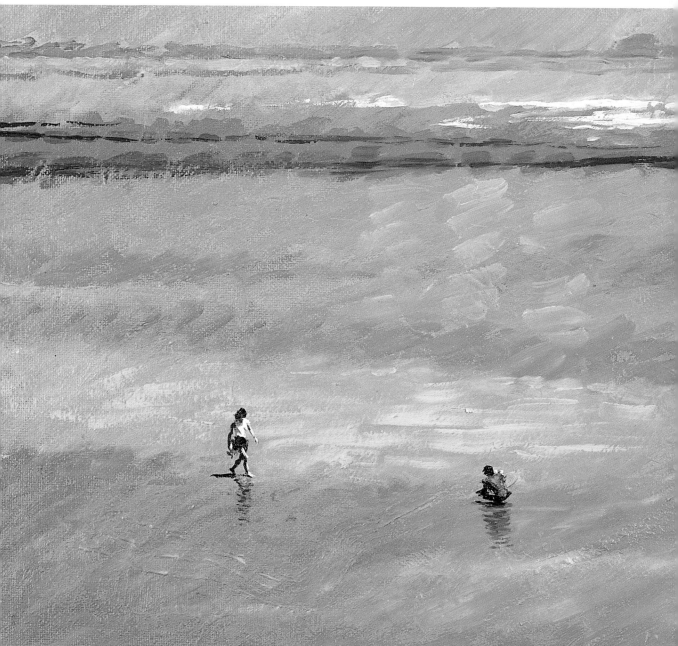

10 By now, the painting was nearly finished. I didn't want to fiddle too much, but I did put some turquoise modelling on the girl's shirt. I also added more pale blue behind the two figures with a large brush and horizontal brushstrokes. Then I was ready to sign my painting – notice how you can use a second brush to steady your painting hand.

11 I'm really pleased with the feeling of freedom as the girl walks across the beach towards the young man. Their juxtaposition in the painting is perfect – she's almost the same distance from the edge of the canvas as she is from him, he's almost in the centre of the canvas, and they're both about a third of the way up the canvas from the bottom. Perfect aesthetic positioning. It's a nice simple painting and the sandy-coloured background colour shows through in places, helping to unify the whole thing.

Running into the Dusk

I took a photo of these runners from a car in Sydney one evening and thought, 'What a great painting this would make.' It was a bit of a task knowing how to deal with this complex picture, but I'm pleased with the result – the fairly casual approach helps give the impression of speed.

1 It was a dark subject, so I worked on a previously primed black background. I painted loosely around where I thought the runners would be, using Cerulean Blue sky colour mixed with linseed oil, and adding white as I neared the bottom. If a silhouette went wrong, I corrected it with a clean bit of rag.

2 Instead of painting shapes that you see, try painting the spaces in between the shapes, aiming to get them as accurate as possible. The bits of background left slightly untouched will give a nice random feeling of action.

3 The last two runners in the second group looked very complex, so – at this stage – I left them as a rough black background blur. The shapes of the other runners had been suggested.

materials
• OIL PAINT
 Cerulean Blue,
 Titanium White,
 Vermillion,
 Cadmium Yellow,
 Lamp Black
• BRUSHES
 A selection of large,
 medium, small and
 rigger brushes
• SURFACE
 Hardboard primed
 with black emulsion
 paint, 60 x 91 cm
 (24 x 36 in)

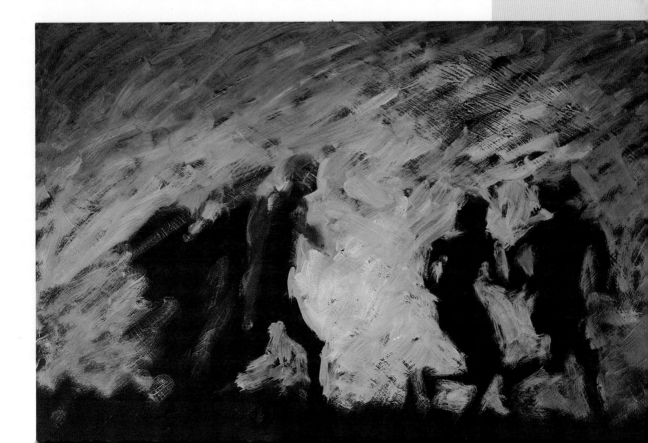

4 At this stage, I began refining the figures of the runners. As I followed their outlines with my sky-coloured brush and made adjustments with my turpsy rag, I knew this picture was going to work.

5 I was still deliberately painting shapes in between the runners, trying to give the impression of daylight revealing the figures on either side. I looked out for interesting features – the man at the front of the second group had a knobbly knee, so I left that in.

6 At the end of this stage, I sponged in some pinkish clouds but I wasn't totally happy with the effect – it looked far too multi-coloured and fussy. However, I decided to leave it and tackle the problem at a later stage. Before continuing, I dabbed lightly over the whole painting with a dry rag to take out any fierce detail and left it to dry for a couple of days.

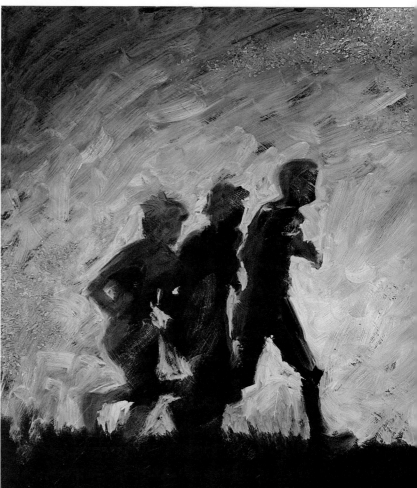

7 When I came back to it, the sky had dried and lost its greasy consistency. I began mixing up some more colours for the runners' clothes and reached for my smaller brushes.

8 I started with a dark blue that would read on the shirt of the leading man, and used diagonal strokes to show the way his t-shirt twisted. The next man needed a turquoise colour to fill in the creases on his top, plus a dirty blue for the modelling on it.

9 I needed plenty of different colours for the runners' clothes, like this dirty pinky-grey and the brown I'm using here. I started a separate brush for each new colour, so they didn't mix. I also used the flat of the brush to get definite strokes for contours of the body and fill in colour.

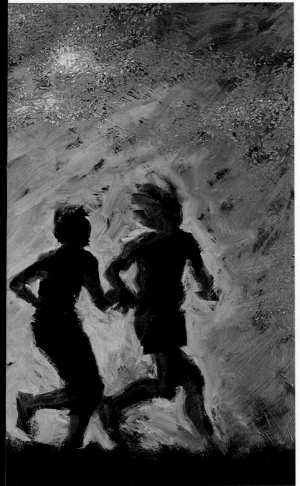

10 By now my runners were really taking shape. I used the edge of my brush to fill in the round lettering, and a dirty brown colour to put in the arms and legs. I had to slightly adjust the tangle of arms on these two figures because they looked confusing.

11 Next I wanted to tackle some of the long bluey-green grasses across the bottom of the picture. I used a tiny sable to do this, and also used the pointed wooden handle of another brush to support my painting hand.

12 I used some fierce black to define the grass at the runners' feet. The random sky helps give the feeling of speed – I've tried to maintain a slap-happy approach throughout to help this impression.

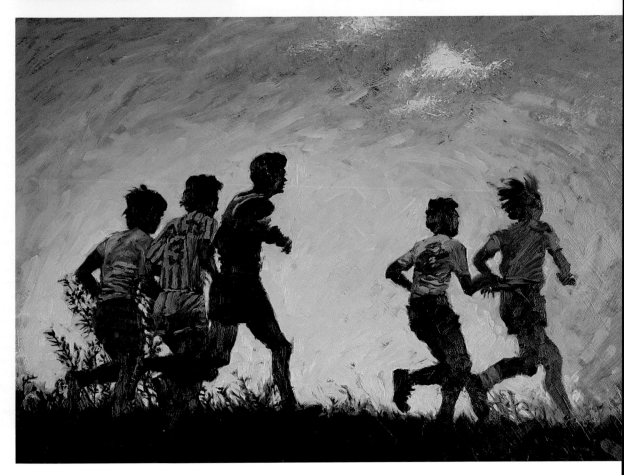

13 Because the original sky was now dry, I was able to mix up fresh, more accurate sky colours to define the shapes of the runners and the grass. You can also see how I'm able to put some interesting detail into this runner's face with a little careful brushwork.

14 The painting was almost finished, but the one thing I wasn't happy about were those fussy pink clouds – I needed to do something about that!

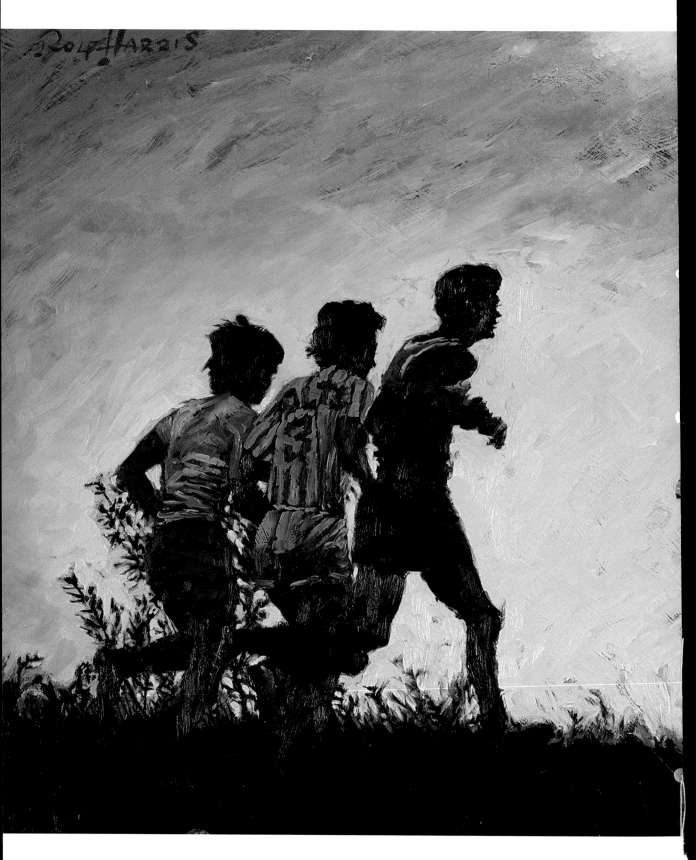

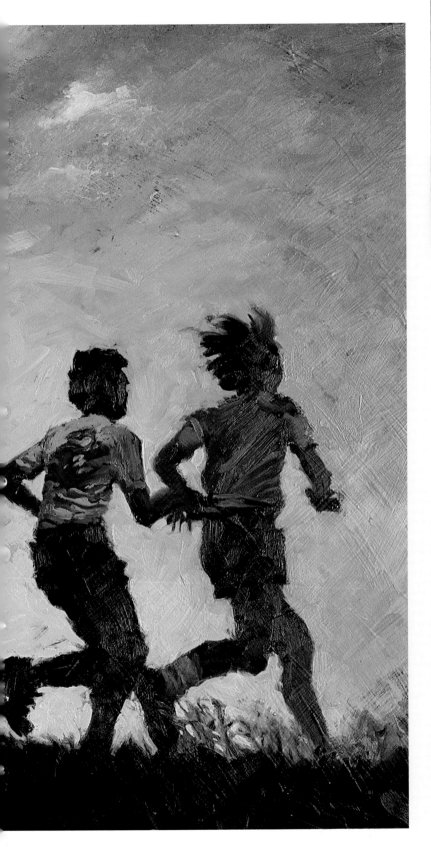

15 I used blue sky colours to paint over the fussy pink cloud effect with the same random brushstrokes I'd used earlier, mixing my paint darker and lighter where appropriate.

16 Then I introduced a lovely dusky pink cloud colour through the sky, and painted a stronger purply colour over it in places. I felt that putting the cloud colours in separately worked a lot better than sponging on this occasion, and I like the way it merged slightly with the still-wet blue sky paint. I really love the optimism of this picture and how all the colours relate. The black underpainting gives terrific strength, and the nice thing is that, against those dark tones, all the other colours are also quite dark but separated. Yes, I'm very happy with this!

Still Life

I wasn't aiming for a pretty picture here but felt that if I assembled a variety of objects, colours and textures together and painted them in a fairly loose, impressionistic way, the result should look pleasing to the eye and demonstrate some of the techniques I use for painting shapes.

1 I started by killing the white canvas with a big brush and a dirty green turpsy mix of French Ultramarine, Yellow Ochre and a dash of Black, splashed on very freely. Then I mixed a little of this dark green with some Cadmium Red and scumbled in the basic shape of the tablecloth with rough brushstrokes.

2 As I worked, I half-closed my eyes to blur the subject and to find the lights and darks for my painting. I used a turpsy rag to start pulling out shapes from the background colour – here I'm working on the handle of the brass jug.

3 I added more body to the brass jug with some of my red mix. I also established the shape of the plate, and took the fierce white of the table-top down a little by scumbling some green over it.

materials

- **OIL PAINT**
 Cadmium Red, Yellow Ochre, Lemon Yellow, French Ultramarine, Cobalt Blue, Cobalt Violet, Cerulean Blue, Black
- **BRUSHES**
 A selection of large, medium, small and rigger brushes
- **SURFACE**
 Canvas, 76 x 50 cm (30 x 20 in)

4 Next, I started loosely putting in the shapes of the fruit with dry brushstrokes, using different yellow mixes for the bananas and the apple.

5 I continued refining the picture, lifting out light areas with my turpsy rag to make them shine out, and adding touches of dark and colour with my brushes – it's lovely when something like this begins to take shape and work.

6 I started establishing the bright blue soda siphon next, using a smaller brush to put in marks to define its general shape, but trying not to get too fussy.

◀ **Rolf's techniques and tips**
Here I'm using a rag to rub out a big highlight on the large brass jug – you can see just how easy it is to do this and what a great effect you can get.

7 By now my painting was really starting to make some sense but I did feel that I needed to re-establish the brilliance of the white paper surface on which my objects were sitting. This would be my next step.

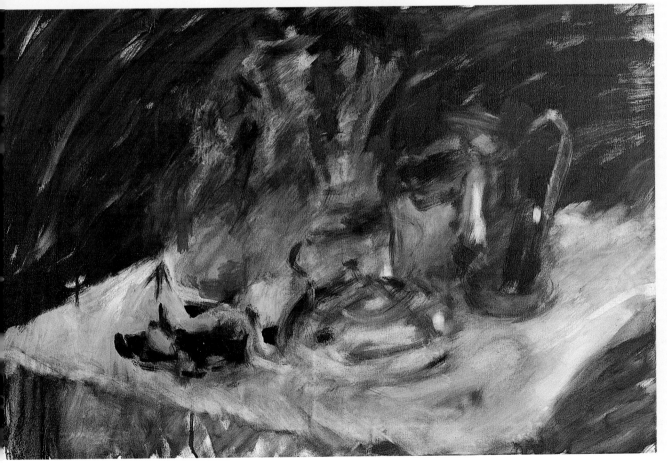

8 I started painting up to the different objects on the table with thick, juicy white paint – this gave a really gutsy contrast and you can see how I was able to define the shapes with the edge of the paint.

9 The blue siphon was too stubby. It needed to be taller in relation to the glass lamp, so I measured and corrected it, strengthening the blue and adding highlights. It was easy to rub out whole areas and redefine the siphon because I still had all the original colours mixed and clean on the palette and on the individual brushes.

10 Next, I added form and detail to the bananas and the apple. When I put the speckles on the bananas, I was very careful because my paint was still wet. Notice the dark shadow between the two bananas and the tiny bit of white tablecloth, both of which really help to show the shape of the bananas.

11 Having mixed colours to tackle the various metals and coloured glasses in my set-up, I continued adding darks and lights to give detail and shape through the painting. These blue and white highlights pick out where light has been reflected on the yellow bottle.

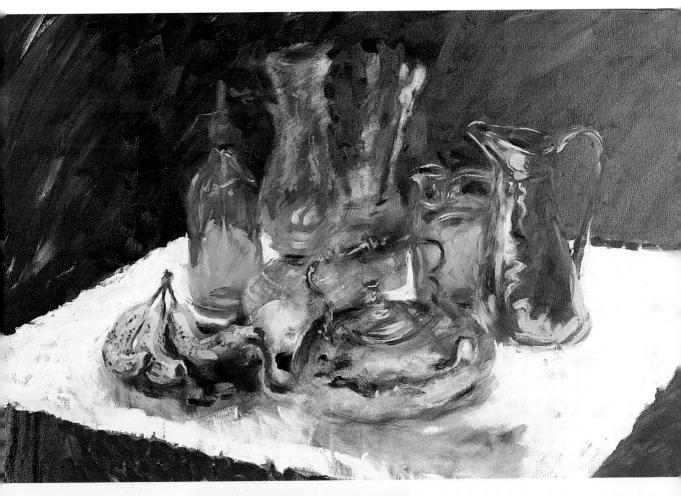

12 You can see how I've used one of the copper jug colours to do reflections on the glass lamp, while the blue highlights on the yellow bottle are repeated on the teapot handle. Use one colour to do as many different jobs as possible – touches like this help to give your picture unity.

13 I really enjoyed painting these brushes, which I did very simply with just a few brushstrokes. Notice the gleaming white highlights on the ferrules and the enamel of the handles. I put them in using a tiny rigger brush and supporting my hand to keep it steady. For the brush-heads, I used downward strokes and my medium brush.

14 When painting in the blue plate, I took my brush right up to the bananas to define their shape really crisply. Then I added a white highlight on the edge of the plate with my rigger brush.

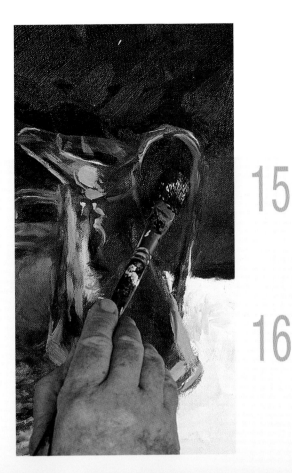

15 I now used my medium brush and more green background colour to creep in and establish any edges that had got lost through the painting. It's important to have enough paint mixed up to use throughout your painting.

16 At this stage, I was very pleased with the picture. I felt that the teapot was a bit too fat but it didn't really worry me. However, the red corkscrew, which I'd put in earlier, was totally wrong in shape and position, and I would need to change that later.

When putting bright yellow highlights onto the brass teapot, I used my paint very liquid to help the tiny fine lines flow on. I also rested on a tall thin brush to support my painting hand.

17 I didn't want to get too fussy with the Indian cloth and copy it exactly, so I just tried to give an impression of the pattern with my rigger. To the right of the table, I made the cloth and pattern much darker and added a dark vertical fold to the cloth to make it 'sit' properly in the painting.

18 It was time to tackle that corkscrew – the shape was much too long, so I decided to rub it out and start again. Never be afraid to take a bit of turpsy rag and rub out something if it's wrong. That's the beauty of working with oils – you've always got the chance to put things right.

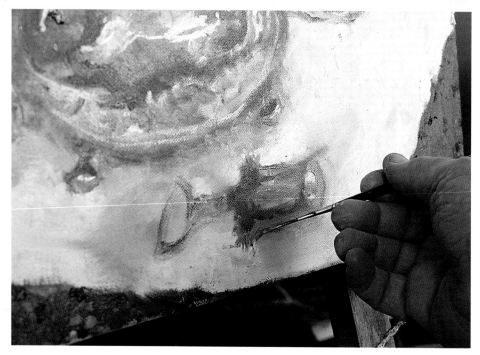

19 I'm very pleased with this picture. I like the way the white defines the objects on the table and I feel my painting represents everything that's there pretty well. I could have been less detailed – my approach does err on the side of the photographic. I can't resist putting in those tiny lines of brilliant light, and it's hard to stop!

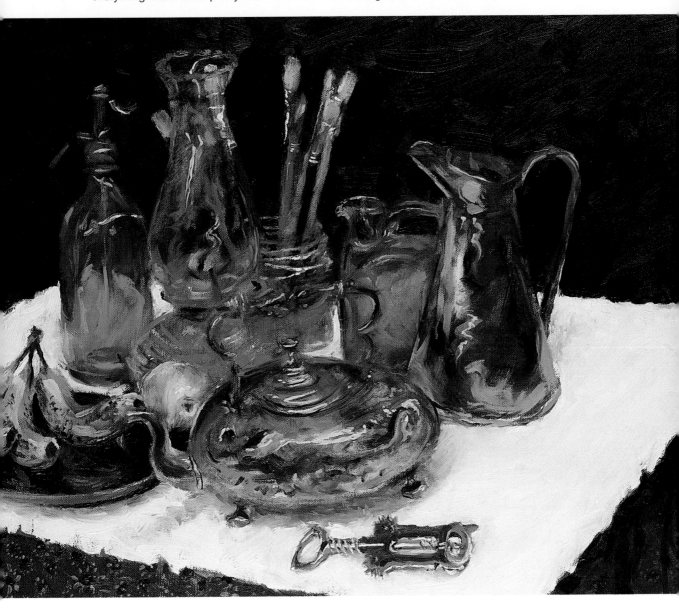

Durham Cathedral

In the 1980s, I saw this view of the cathedral and it was magic. For this painting, I worked from my pencil sketch and an enlarged photograph for extra information. I used scenery paint on a huge piece of hardboard, and my style was similar to the one I used on TV all those years ago.

1 I began by putting in the background. The earth was done with free back-and-forward brushstrokes and an orangey mix of red and yellow, to which I added some white for the sky area. Throughout this painting, I had all my colours mixed in separate pots in large enough quantities to be wet and available at all times.

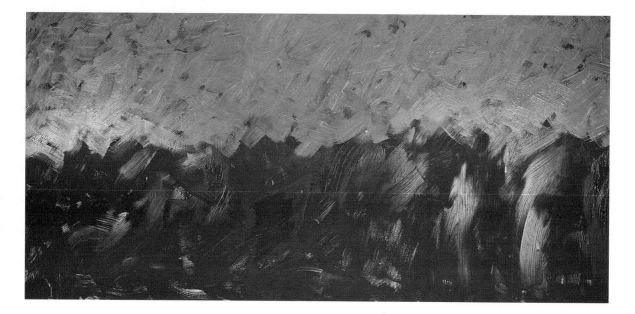

◀ **Rolf's techniques and tips**

When half the bristles fell out of a big brush, I discovered what a good painting edge it gave! You can cut half the bristles out of a 100 mm (4 in) decorator's brush to get the same effect.

materials

- SCENERY PAINT
 (liquid emulsion paint in cans)
 Smalt Blue, Cadmium Yellow, Lemon Yellow, Light Blue, Red, White, Prussian Blue, Black
- BRUSHES
 100 mm (4 in) and 75 mm (3 in) flat decorator's brushes and 12 mm (½ in) flat sable brushes
- SURFACE
 Hardboard, 107 x 207 cm (42 x 82 in)

2 When the background was dry, I mixed some misty blues and yellows that would read against each other in my painting. I checked this by flipping a tiny fingerful of one paint onto the surface of the next pot and comparing the two colours. Then I loaded my brush with light blue paint and put in some key features, starting with the central steeple.

I made up a darker blue to put in detail. Because I'd mixed up plenty of background paint, if I wasn't happy, I could easily cover bits up and start again. I used a smaller brush and a darker colour to lay in all the rest of the buildings and put in the darkest bits.

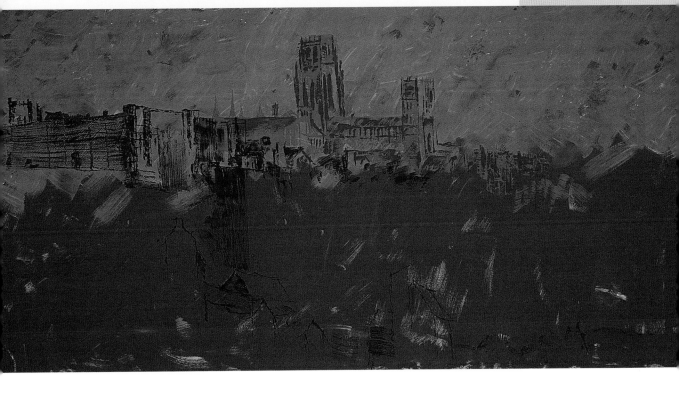

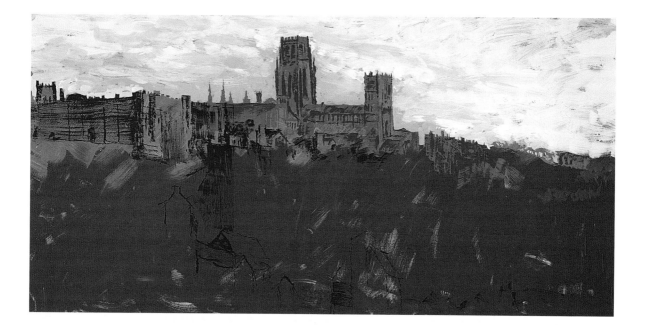

3 For the sky, I mixed up Prussian Blue and White, with a little orange background colour to kill the prettiness. I made a slightly darker blue to read against it in places to form clouds. I filled in the bigger bits of sky with broad, sweeping strokes

4 I was more careful when painting up to buildings with my sky colour, and used a smaller brush. If anything was crooked, I was able to adjust it with new brushstrokes.

I used the darkest blue paint to scumble over some of the foreground with rough brushstrokes, letting some of the underpainting show through.

5 I mixed Prussian Blue and Cadmium Yellow (again dirtied up with my background colour) for the dead winter foreground foliage. I popped them in with my big brush and dry brushstrokes, scumbling over the background colour. I added a dash of Lemon Yellow to the mix for the green field (in a separate pot, of course).

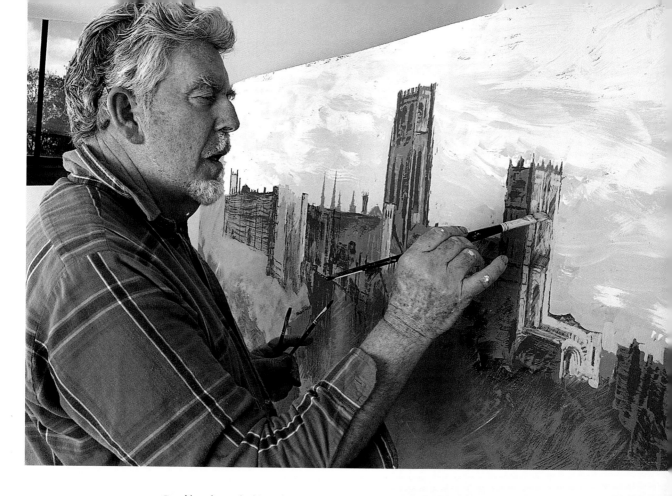

6 Now I needed to mix some colours for the façades of the buildings. I started with Cadmium Yellow, mixed with background colour, and used this to put in the mid-lights and pick out architectural features. I then made a slightly darker colour to do the dimmer areas by adding Prussian Blue to the mix.

7 Next, I needed to deal with the brilliant light hitting the sides and roofs of some of the buildings. I used almost pure Lemon Yellow for this, with a bit of White added.

8 I used black paint to pick out details throughout the painting, looking out for interesting features like the windows and doors on the castle.

9 I fixed the trees on the right, using my blue paint mixes. I also painted some light sky background down to the trees, adding a touch of dark dirty-looking red along the base of them to make them zing out of the picture.

10 Then I lightly scumbled some background colour over practically the whole painting, knocking back any areas that I felt looked a bit too fierce.

11 When I stood back from the previous stage, I saw that the tower in the centre looked wrong – it was leaning to the right! It just shows that you should take time to step back from your painting, especially if it's a large one! I put things right, and I'm very happy with the way it turned out. I love the way the first background brushstrokes show through in places – but I could have been braver and not put in so much tiny detail. It's important to know when to stop!

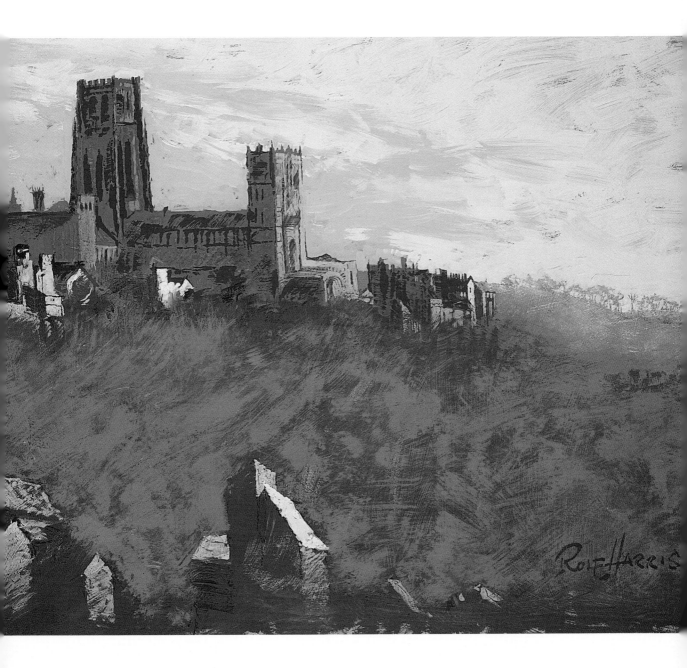

The Didgeridoo Player

My friend and didgeridoo player Shining Bear is – at 1.93 m (6 ft 4 in) tall – an impressive, larger-than-life character, and for years I've wanted to paint his portrait. When he returned from a trip to America, wearing a striking cowboy outfit, it was just the spur I needed...

1 I decided to make the black of the clothes into a more interesting purple colour. To kill the white of the canvas, I mixed Emerald Green, Viridian and Lemon Yellow with lots of turpentine to make a green that was completely opposite on the colour wheel to the purple I was going to use on the clothes. Applying this like a watercolour wash, I got rid of all that intimidating expanse of white and started roughly positioning all the elements of the picture. I used turps on a rag to lift off dark bits I didn't like.

2 I continued to use a rag to roughly position Bear's facial features and other key features like his bootlace tie and the didgeridoo. Throughout the picture, I kept measuring to check that I was getting the right proportions and putting things in their correct positions.

3 I realized that the line of the didgeridoo wasn't at the right angle, so I corrected this with my damp rag, lifting out a line of light along the top edge of it.

materials

- OIL PAINT
 Emerald Green,
 Viridian,
 Lemon Yellow,
 Titanium White,
 Permanent Blue,
 Cobalt Violet,
 Cadmium Yellow,
 Chrome Yellow,
 Cerulean Blue,
 French Ultramarine,
 Permanent Magenta,
 Black
- BRUSHES
 A selection of large,
 medium, small and
 rigger brushes
- SURFACE
 Canvas,
 100 x 75 cm
 (40 x 30 in)

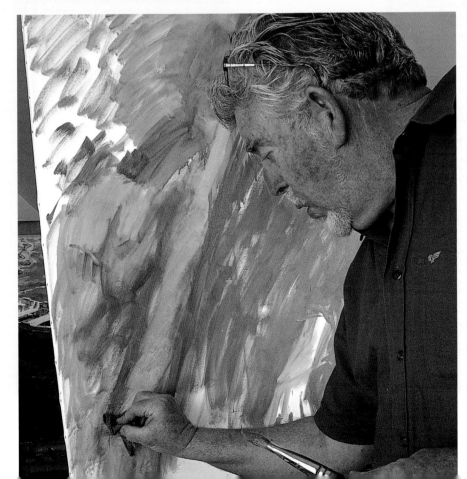

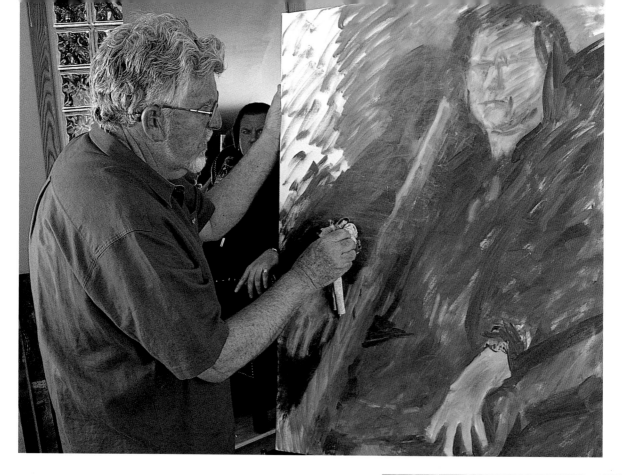

4 Now I started to deal with different bits of the painting, putting in light and dark to get the shapes right. I covered the canvas as quickly as possible, not worrying about fine detail, but roughly positioning the hands, the hat and the angle of the chair arm. You need plenty of clean rags for this sort of approach. I then left the canvas to dry before rubbing off any surplus wet paint, so newly mixed colours wouldn't pick this up.

5 Having cleaned my palette of all the background colour, I mixed up four tones of purple from a blackish colour to bright violet. Then I started positioning some important darks above the ear and around the chin.

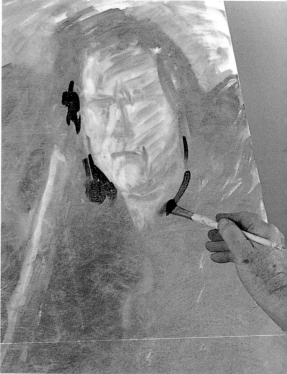

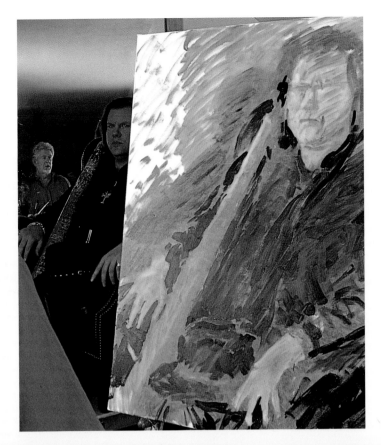

6 Using a new brush for each colour, I started putting in the new colours to see how these would work. At any time in your painting, you can use a rag to take off colour that doesn't look right – if you try to mix it on your canvas, the colour will get all muddied up.

7 I knew the didgeridoo would be fun to paint, and mixed up some browns to do it. I would need shades to echo the earth colours used by Aborigines.

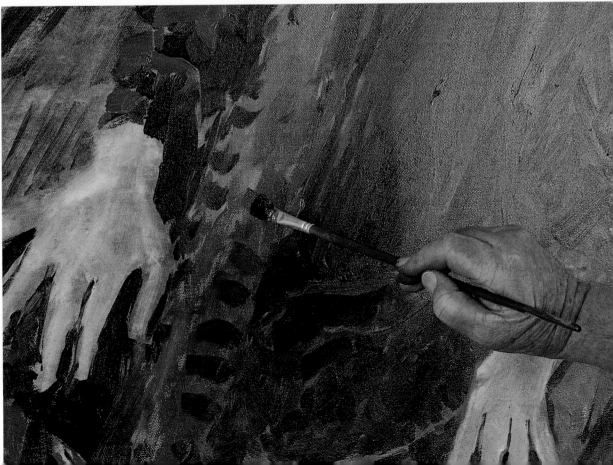

8 I mixed up some hair and flesh tones and started roughly putting in facial details and the outline of Bear's hair, always screwing up my eyes to look at my subject to find the different darks and lights in the picture. I changed to a smaller brush to put some detail into the eyes.

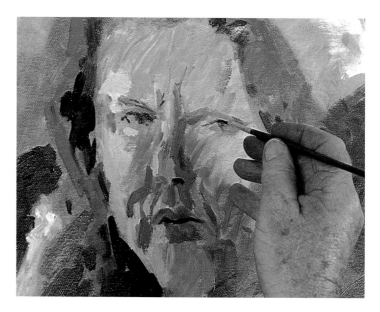

9 It was time to deal with some detail on the clothes. Using the darkest colour and thick paint, I put in the swirly patterns on the waistcoat, then painted up to them with the lighter violet colour.

10 Key elements that should really zing out of the picture and bring interest to Bear's dark clothes were the clasp and metal ends on his bootlace tie. I used pure Titanium White for these.

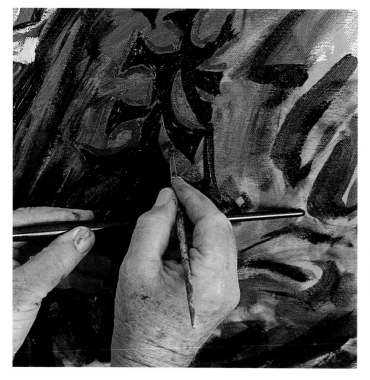

11 I also put a bright line of white round the hatband and used more of the body colours to give shape and detail to the hat. This hand wasn't right so I mixed up some dark flesh colour and positioned it more accurately.

12 It helps when you're trying to get hands right to remember that they are quite large – if you put the heel of your hand on your chin, your fingers should reach up to your hairline. Also remember to accurately paint the shape of the spaces between the fingers.

13 I used a couple of different colours to try and pinpoint accurately the highlighted areas on Bear's face. The accurate position of the bluey-grey shadow areas should give reality to the features. I used a bit of the brown from the didgeridoo for highlights in the hair, and realized after measuring again that the eye on the right was in the wrong place.

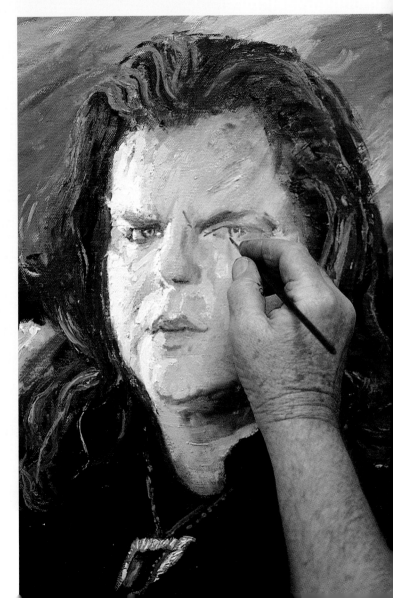

14 I used the pinkish secondary highlight tone to catch the little extra bumps of light on the forehead. Literally daubing it on with the end of the brush gives you wonderful control.

15 Doesn't the didgeridoo look lovely? I needed a steady hand to put in all those little dots and brushstrokes, so I used a big brush with just its wooden tip touching the canvas to support the wrist of my painting hand. This kept my painting arm from smudging the wet blue and purple paint underneath.

16 Sitters quite often say, 'You've made me very serious,' but it's really difficult for them to keep the same pose for several hours and look smiling and happy throughout. I have come up with a very severe look on my didgeridoo player, Shining Bear, but I think the portrait grabs you, and the dark purply look of the clothing is quite impressive. I like the way I've left the original roughly sloshed-on green colour to the top left of the picture. There's nothing important happening there and it looks very relaxed.

Sunrise at Bray

In different years, I'd taken two photographs from the balcony of my home at Bray – one at sunrise and another showing the winter snow and the reflections of the trees in the water. I used both for reference and did this painting with scenery paint.

1 I had already coated the hardboard with several thick coats of black emulsion paint and let it dry. The rough surface gave a nice random texture on which to work. Having mixed some strong colours, I started putting in the sunset, which stood out vividly against the black.

2 I put in the reflections of the sunset in the water with a dry brush technique. Scenery paint dries fast, so I had to wash my brushes out frequently in water.

3 I mixed some purply-blue for the sky and started putting this in with my big brush – I let it go over the sunset in places to get little bits of clouds happening.

4 Adding a little yellow to my sky mix gave a more greyish, muted shade. I put some of this into the sunset colours to create clouds. I also put some on the reflections.

materials

- **SCENERY PAINT** (liquid emulsion paint in cans) Tapestry Blue, Smalt Blue, Mauve, Cadmium Yellow, Lemon Yellow, Red, Black, White
- **BRUSHES** 100 mm (4 in) and 75 mm (3 in) flat decorator's brushes and 12 mm (½ in) flat sable brushes
- **SURFACE** Hardboard, 91 x 61 cm (36 x 24 in)

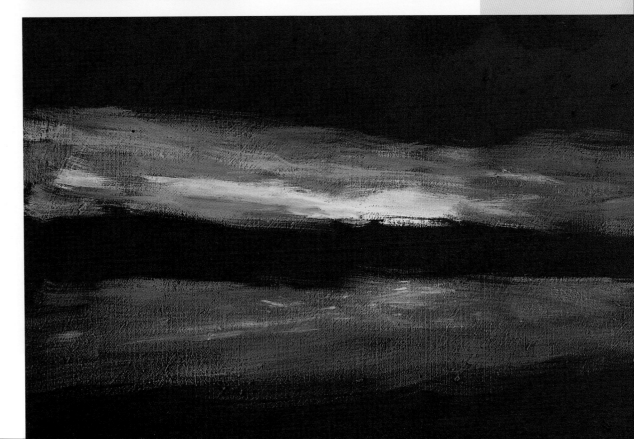

◀ **Rolf's techniques and tips**

If globs of paint stick out on the canvas, don't be afraid to use your finger to correct things!

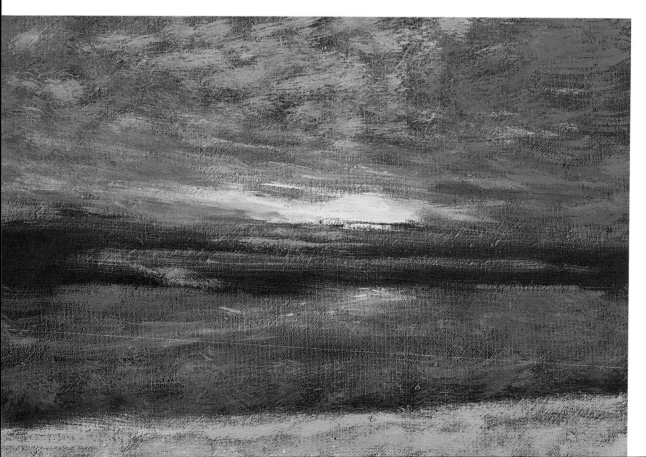

5 Next, I scumbled over the painting so the original hardboard texture didn't show through quite so strongly. Then I used more of my sky colour mix to start putting in the opposite bank below the sunrise, adding bright bits including the roofs of the house.

6 Everyone thinks that snow should be white but, in a dark scene like this, it picks up and reflects the blue of the sky above. So I used pale blue for the snow in the foreground at the bottom of the picture, making it fairly horizontal instead of having it run fiercely uphill.

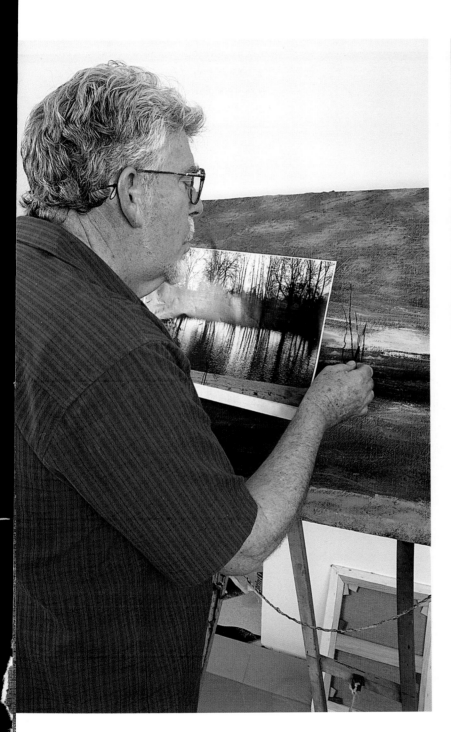

7 Once the paint was completely dry, it was time for the trees. I loaded a rigger brush with black and started putting in all the lovely silhouettes. I was trying to pinpoint every branch that did something – curvy ones and straight ones – remembering that trees must gradually get thinner as they go upwards or they won't look real.

8 I also put in some rough-and-tumble stuff, holding my brush in a looser way to tackle foliage. With a painting like this you couldn't paint the background in last; it would be impossible – there's too much happening in front.

9 My next job was to establish where the waterline on the far bank should be – I felt that it would look strange if it wasn't horizontal, so I measured from the bottom of the board with my rule and straightened it up.

10 Next, I started carefully painting the reflections of the trees in the water. If you gently zig-zag your brush as you work down, it will give an impression of moving water with the reflections broken up by the breeze.

11 Now it was time to put in the big willow tree on the near bank. I began this with a medium-sized brush but changed back to my rigger for the smaller, hanging branches. This tree was really intricate!

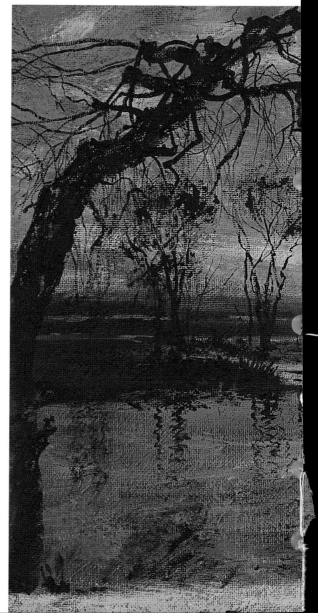

◀ **Rolf's techniques and tips**

Remember, if all your underpainting is completely dry, you can rest your little finger on the canvas to help support your hand when painting fine detail.

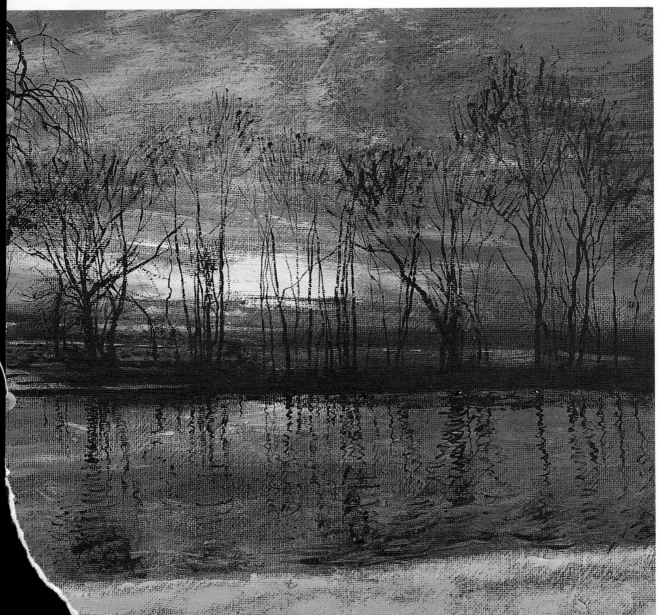

12 Now for some final details, like painting this brilliant bit of Lemon Yellow for the sun – doesn't it look gorgeous?

13 I finished by painting some little trees on the near bank, scumbling over the snow with darker blue paint to make it crisper, and adding some ducks in black and dark blue on the river to pull that part of the picture together. The end result? I was thrilled to bits with it!

South London Flower Seller

When I was driving on my way to Brixton over 25 years ago,

I saw this wonderful man and his flower stall. I just had to stop and

catch it on camera. For this demonstration, I decided to start the

painting by turning my reference photo upside-down!

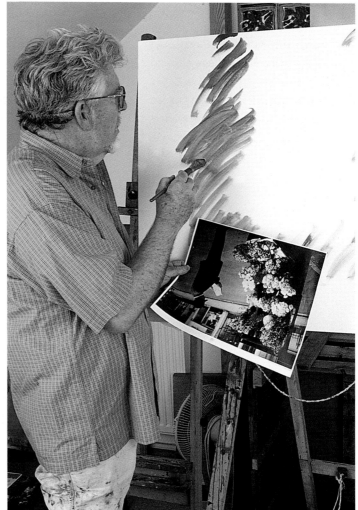

1 Painting an image upside-down really helps you to put in the main features without becoming bogged down with details like: 'Here's his nose, and here's his ear.' Upside-down, you hardly recognize things and can just concentrate on getting shapes, colours and tones right. I started with a turpsy mix of Cobalt Blue, mixed with some other colours left on the side of my palette to get a dirty blue for my background colour.

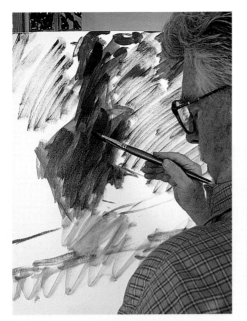

materials

- **OIL PAINT**
 Cobalt Blue, Cadmium Red, Cerulean, Viridian, Zinc White, Cadmium Yellow Pale, Lamp Black, Cobalt Violet
- **BRUSHES**
 A selection of large, medium, small and rigger brushes
- **SURFACE**
 Canvas,
 100 x 75 cm
 (40 x 30 in)

2 I began tackling the darkest areas first, putting in the shape of the man's figure very loosely with big, rough brushstrokes. Then I mixed up some brown paint and started to establish the road and background.

3 I used a rag to rub off paint where the rows of flowers on the stand would go, and to position the man's newspaper. Because the paint had been diluted with lots of turpentine, it was easy to move it around and to lift it off the canvas.

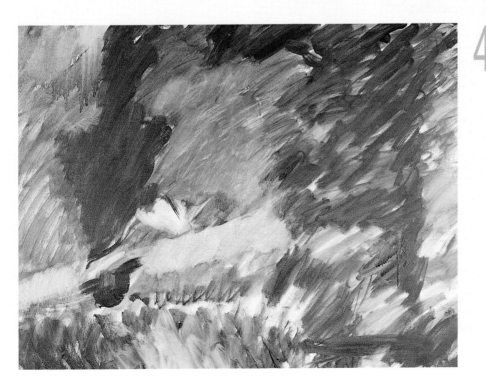

4 I also lifted out colour to reveal the pavement that went up behind the man's head. By now the canvas had been completely covered with paint and I had begun to establish some of the tonal relationships in the picture.

5 I loaded a smaller brush with Cadmium Red to put in the rough shape of the man's head. I used the same colour for his hands, and also positioned some of the clumps of red flowers on the stand with free, diagonal brushstrokes.

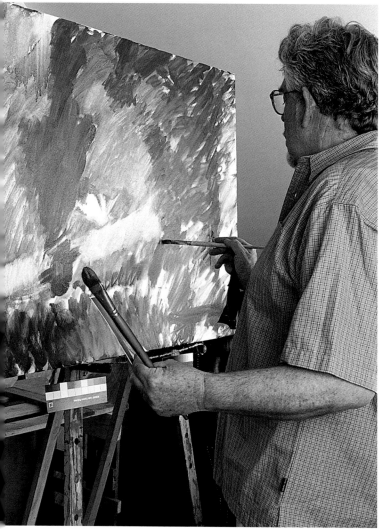

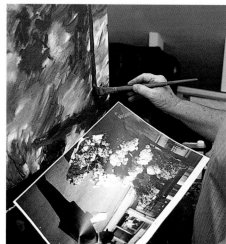

6 Using my rag, I pulled out colour to leave the rounded shape of the man's back. I also used my rag to lift out areas where the light bunches of flowers would go on the flower stand.

7 I continued putting in the shapes for large chunks of colour with brown paint and lifting out the pale areas that were in my upside-down photograph. Then I used a darker brown to establish the side of the stand.

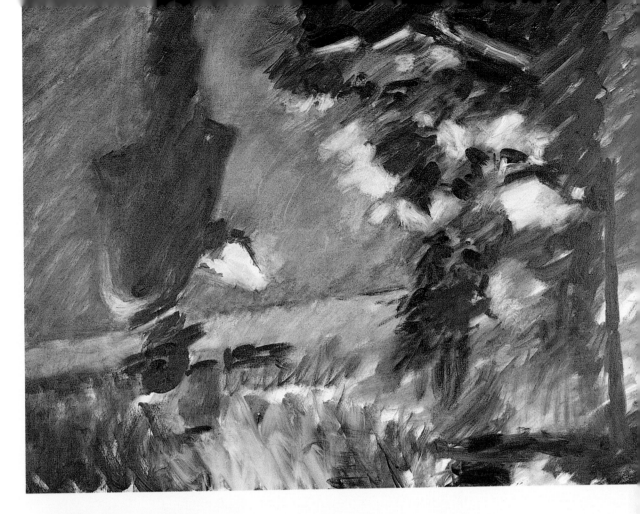

8 The angle of the pavement behind the man's back was far too fierce, so I painted over this. Then I used a turpsy rag to pull out a new position for the pavement, which looked far better. The other one had been completely wrong!

9 It was now time to take a break and leave my painting to dry for a while, before rubbing it over lightly with some clean rag to remove the bulk of any thick wet paint left that could mix with new colours. Then I turned the painting the right way up.

10 I painted in the man's hat, jacket and trousers with bold diagonal brushstrokes, using the edge of my brush for the folds of his jacket – I love the way it rides up at the back! I put pure white on his newspaper, leaving some background colour showing through to give the illusion of print. Then I refined the shape of his face, using black paint to put in features.

11 I started putting in some of the green foliage, using dry brushstrokes to put in the tall leaves at the top. Then I used black paint to fill in the back of the flower stand canopy, leaving room to put blossom in later.

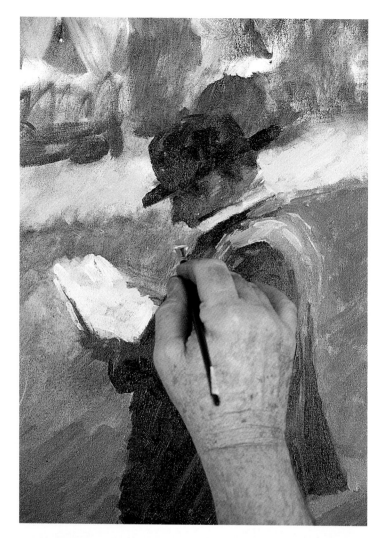

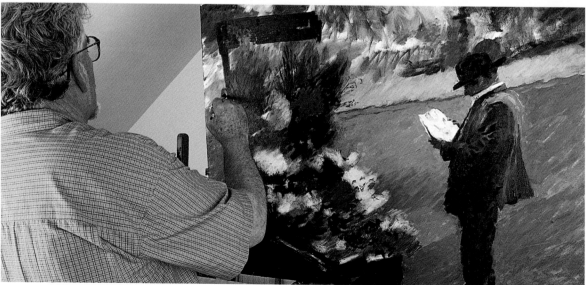

12 Next I turned my attention to the shop fronts at the top of the picture, and started putting in very loose detail to establish the lights and darks of wood, metal and windows, and the colours that showed from within the shops.

13 As usual, I used a different brush for each colour, to make sure that it didn't get mixed up with other colours and become muddy.

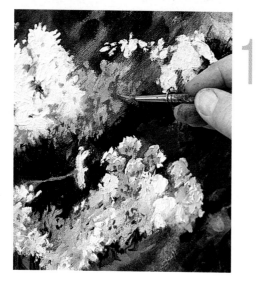

14 I knew that I was really going to enjoy painting the flowers. I left it for two days to make sure the background was dry and reached for my smallest brushes, beginning with the little yellow daisies and using thick paint to give texture to the blooms. I also tried to get the impression of spiky edges of petals in places.

15 For the carnations with frilly petals, I used different pinks and let the wet colours intermingle. Of course, there are no hard-and-fast rules to painting, and you can even use your finger to dab on paint if you want!

16 You don't need to paint every flower perfectly – if you pick out a few important blooms, the eye will accept what kind of flowers they are.

17 With something that contains so much detail, it is very difficult to know when to stop. It would be wonderful to paint against a stopwatch, as I used to have to do with my huge television paintings. In that case, you had to leave it, you couldn't go back and do fiddly little corrections and try to make it look more like a photograph. I'm very pleased with this one, though, and thrilled to pieces with the man.

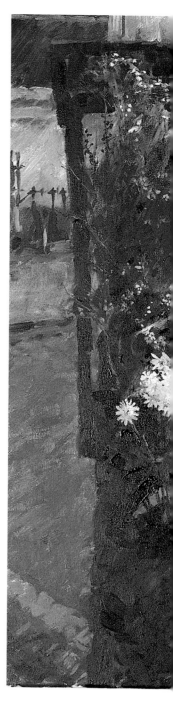

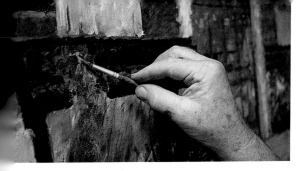

◀ **Rolf's techniques and tips**

*You can hold your brush in lots of
different ways to achieve different
effects and brushstrokes, so it's
worth experimenting. Here I was very
free with my dry brushstrokes, and
scumbled over the canvas in places.*

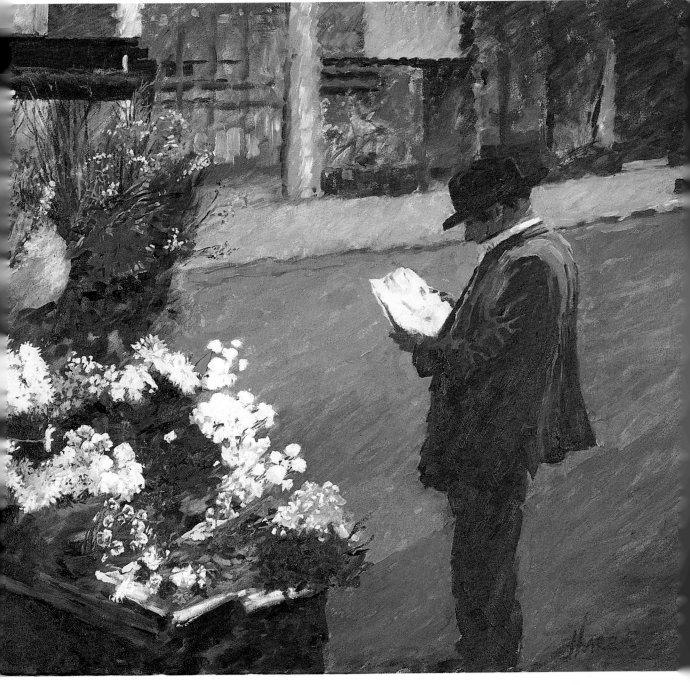

A QUESTION OF ART . . .

After the first television series of Rolf on Art, *I took part in a live chat on the Internet. Here are my answers to some of the questions I was posed. I hope you enjoy reading them and seeing some more examples of my work over the years.*

What advice would you give to budding artists?

Be happy to paint and learn from your painting, rather than trying to create a great work of art every time. Never throw things away, even if you don't think they work – keep them to look back on at a later time. Learn to look at things and work out what you're seeing – look for colours and shapes in everything. Don't be scared to be a little bit outrageous and, above all, have fun!

Robert Harbin, 1975

Oil on hardboard
60 x 80 cm (24 x 31 in)

Magician Robert Harbin became a mentor and a friend during my first days in television. Before the sitting, I covered the paint-splattered hardboard with Prussian Blue and turpentine, propped it over an oil heater to dry, and when it got too hot, picked it up and fanned it to cool it down. I heard the whoop, whoop, whoop and thought, 'What a great sound!' Bob loved the picture but never got it – it became my first wobbleboard!

Regent's Park, 1954

Oil on canvas
58 x 73 cm (23 x 29 in)

This was the first impressionistic painting I ever did out-of-doors. One autumn day, I set up my easel in Regent's Park, did a tonal rough sketch with a light brown-coloured turps and paint mix, then built my picture up from there. The lady walked by with her little dog, which was nice. I often wonder if I should have made her coat red, which would have really jumped out of the picture. I sometimes go back, and that lovely central tree is still there.

Which medium would you recommend to a beginner with a longing to draw and paint – watercolour, oils or acrylics?

I prefer oils. With watercolour, you really have to plan your painting like a battle campaign and know exactly what you're going to do with a wash of colour, and how to flood more colour into it when it's almost dry. You have to be in constant practice to get everything just right. You also have to paint watercolours more vividly than you expect – when they dry, the painting loses vibrancy and appears too pale, in the same way that beautifully coloured pebbles from the sea lose their colour when they dry.

Acrylic colours are good because they dry quickly and you can paint over them rapidly. You can also use acrylic paint mixed with water, like watercolours, or as thick body colour, like oils, so you have the best of both worlds. However, because they dry so quickly, they also tend to clog up your brushes, so you need to keep washing them, while with oils you can pick your brushes up or put them down at will. Acrylics dry a slightly different tone than they are when wet. With oils, the colour dries the same tone as it is when wet. Best of all, if you make a mistake, you can wipe it off or let it dry and paint over it.

Picture of Mum, 1975

Acrylic on canvas
75 x 53 cm (30 x 21 in)

I think this is the best picture I've ever done. It took just an hour to paint – I did it very loosely – and everything worked like a dream. Using one colour to do several jobs really helps to unify a picture, and I used this technique a lot through this painting. You can see I used the same pale green in vertical chunks of curtain behind Mum's face and also as the lighter colour in her grey hair. Then the slightly darker dirty green shadow in those curtains is used as the next darkest hair colour, in Mum's teeth, and for various bits of shadow from the nose to the chin. They look like different colours because they are doing different jobs in different places.

Picture of Dad, 1975

Acrylic on canvas
75 x 53 cm (30 x 21 in)

In this picture of Dad, I didn't tackle the hands very well – the canvas was just a bit too small to take them in properly in the scale I was using. By the time I realized I wasn't going to be able to fit the hands in properly, the face area had developed so well, I wasn't going to change the scale for anything! What did really work was the way that, on the left-hand side of the picture, the edge of the cheekbone has been defined by just a dark bit of shadow, and the rest of the cheek and shoulder run straight off into an identical background colour with no line to identify where they end. If no line is visible, don't paint it – the impression will work if you paint what you see.

Why does painting inspire you?

I think that both drawing and painting are magic. From a blank piece of paper or canvas and an idea in your head, you can create something from absolutely nothing. Try watching a child drawing – it's mesmerizing. Only they know what's coming next, and there is no limit to what they can draw. It is like a universal language that crosses all borders and cultures, captivating children and adults alike. It could even be called the ultimate form of magic. From that blank page, the options are infinite and nobody knows what will emerge except the artist.

Harbour Boat, Malta

Oil on canvas
75 x 100 cm (30 x 40 in)

This was done from a photograph taken years ago. The joy for me was the stunning orange against the blue-green of the water, and the reflections. It is a really good, aesthetically pleasing composition – the boat is just a third of the way from the left and a third of the way down from the top, while on the other side the reflection of the mast of the boat is right on the dividing line of the other third of the picture.

INDEX

acrylic paint 125
After the Bath (painting) 32–3
 (Degas) 30
Ambassadeurs: Aristide Bruant
 (Toulouse-Lautrec) 55
approach to impressionism 8–9
At the Races (Degas) 31

Baby Blues (painting) 9
Beethoven Frieze (Klimt) 60
Bindi's Hands (sculpture) 63
brushes 11
 tips for using 72, 93, 123
budding artists, advice to 124

Cancan at the Moulin Rouge (painting) 56–7
The Cathedral (Rodin) 63
The Church at Auvers (painting) 38–9
 (Van Gogh) 38
Church and Cedar (sketch) 21
colours 10
 mixing 12–13
composition 14–15
Coventry Cathedral (sketch) 21

The Dance at the Moulin Rouge
 (Toulouse-Lautrec) 54
Degas, Edgar 30–5
The Didgeridoo Player (painting) 100–7
The Dream (Gauguin) 45
dry brushwork 32
Durham Cathedral (painting) 92–9

easel 12

Gauguin, Paul 44–9
 and Van Gogh 37
Golden Jubilee Frieze (painting) 60–1

Harbour Boat, Malta (painting) 127
Houses of Parliament (painting) 28–9
 (Monet) 24
The Hungry Lion (painting) 52–3
 (Rousseau) 50

Impressionist movement 24–5

The Jockey (painting) 34–5
jungle scenes 50, 52–3

The Kiss (painting) 59
 (Klimt) 58
Klimt, Gustav 58–61

leaves, painting 29, 43
light changes 28
lithographic process 55
Love at Low Tide (painting) 19, 68–73

Man with Bike, Malta (painting) 14–15
Man Leaning (sketch) 19
Martinique Landscape (Gauguin) 44
materials and equipment 10–12

measuring 16
mediums 11
mistakes, correcting 8, 10, 40, 42
Monet, Claude 24–9
monochrome, exercise in 8, 9
movement, painting 34–5
Mrs Mundy (painting) 18
Myself: Portrait Landscape (Rousseau) 51

observation 16
oil paint 10, 125

painting surfaces 12
palette 11
palette knife 11
pastel 32
peinture à l'essence technique 56
people, painting 17–19
photographs, using 14–15, 31, 34
Picture of Dad, 1975 (painting) 126
Picture of Mum, 1975 (painting) 126
portraits 9, 18, 100–7, 124, 126
 see also self portraits
posters 55
proportion, measuring 16

questions and answers 124, 125, 127

reflections, painting 27, 29
Regent's Park, 1954 (painting) 125
Robert Harbin, 1975 (painting) 124
Rodin, Auguste 62–5
Rolf on Art (poster) 55
Rolf's Dream (painting) 46–7
Rolf's Thinker (sculpture) 64–5
Rousseau, Henri 50–3
Running into the Dusk (painting) 19, 74–81

scenery paint 92, 108
sculpture 62–5
scumbling 95
self portraits 17, 40–1, 51
 Rousseau 51
 Van Gogh 37
series paintings, Monet 25
shadow areas 41
shape and form 9
sketching 19, 20–1
South London Flower Seller (painting)
 116–23
Still Life with Blue Bottle (Veal) 8
Still life (painting) 82–91
Sunflowers (painting) 42–3
 (Van Gogh) 36
Sunrise at Bray (painting) 108–15

techniques and tips 72, 85, 90, 93, 95, 110,
 113, 121, 123
The Thinker (Rodin) 62
toothbrush, using a 59
Toulouse-Lautrec, Henri de 54–7

Trees and Graffiti (sketch) 20
Tropical Vegetation (painting) 48–9

upside-down image, use of 116–19

Van Gogh, Vincent 36–43
Veal, Hayward (Bill) 8, 9
Vienna Secession 58

The Water Lily Pond (painting) 26–7
 (Monet) 25
watercolours, using 125
Woman with Pram (sketch) 20

Picture Credits:

Paintings by Rolf Harris © Rolf Harris

All photographs of Rolf Harris and his paintings by Richard Palmer © BBC Worldwide Ltd, except those images on pages 27, 29, 35, 39, 41, 43 and 49 courtesy of the Halcyon Gallery, London and pages 12 and 33 © James Meaneaux Stenson/BBC. Original photographs by Rolf Harris on pages 14, 68, 74, 108, 116 © Rolf Harris.

Claude Monet: page 24 'Londres, le parlement, trouée de soleil dans le brouillard', p. 25 'Le Bassin aux Nymphéas: Harmonie Verte' © Photo RMN – H. Lewandowski/Musée D'Orsay, Paris; **Edgar Degas:** p. 30 'After the Bath, Woman drying herself' © National Gallery, London; p. 31 'Le champ de courses, jockeys amateurs près d'une voiture' © Photo RMN – H. Lewandowski/Musée D'Orsay, Paris; **Vincent Van Gogh:** p. 36 'Vase with Sunflowers', Amsterdam, Van Gogh Museum (Vincent Van Gogh Foundation); p. 37 'Self Portrait' © Photo RMN – Gérard Blot/Musée D'Orsay, Paris; p. 38 'L'église d'Auvers-sur-Oise' © Photo RMN – Hervé Lewandowski/Musée D'Orsay, Paris; **Paul Gauguin:** p. 44 'Martinique Landscape (Vegetation Tropicale)', National Gallery of Scotland; p. 45 'Te Rerioa' ('The Dream'), Courtauld Institute Gallery, Somerset House, London/Bridgeman Art Library; **Henri Rousseau:** p. 50 'Le Lion, ayant faim, se jette sur l'antilope', Private collection, Basel/AKG; p. 51 'Myself: Portrait-Landscape', Narodni Galerie, Prague, Czech Republic/Bridgeman Art Library; **Henri de Toulouse-Lautrec:** p. 54 'La Danse au Moulin Rouge', The Philadelphia Museum of Art, Pennsylvania, USA/Bridgeman Art Library; p. 55 'Ambassadeurs – Aristide Bruant', Bibliothèque Nationale, Paris/Bridgeman Art Library; **Gustav Klimt:** p. 58 'The Kiss', p. 60 'The Beethoven Frieze – panel showing 'The Knight', Österreichische Galerie Belvedere, Vienna, Austria/Bridgeman Art Library; **Auguste Rodin:** p. 62 'The Thinker', Musée Rodin, Paris/Bridgeman Art Library; p. 63 'La Cathédrale', © Musée Rodin, Paris.